CARAVAGGIO

CARAVAGGIO

Timothy Wilson-Smith

1999

Phaidon Press Limited
Regent's Wharf, All Saints Street, London N1 9PA

First published 1998
© Phaidon Press Limited 1998

A CIP catalogue record for this book is available from the British Library

ISBN 0 7148 3485 8

Printed in Singapore

The publishers would like to thank all those museum authorities and private owners who have kindly allowed works in their possession to be reproduced. Particular acknowledgement is made for the following: AKG, London: figs. 16–18 and Plate 27; Alinari, Florence: figs. 15, 21, 24, 26–9, 34, 37–9, 41 and Plates 33, 34, 40 & 48; Bridgeman Art Library, London: fig. 36; Foto Saporetti, Milan: fig. 14; Foto Vasari, Rome: figs. 8 & 9; Index, Florence: Plate 24; Institut d'Amatller d'Art Hispanic, Barcelona: fig. 22; Maurizio Marini, Rome: figs. 5 & 33; Publifoto, Palermo: fig. 42; RMN, Paris: figs. 23 & 39; Scala, Florence: figs. 1–4, 6, 10, 12, 13 and Plates 1, 3, 4, 7, 8, 10–12, 15–19, 21, 25, 28, 29, 31, 32, 37, 38, 41, 43, 44.

Cover illustrations:
Front: *Bacchus*, c.1597 (Plate 10)
Back: *Judith Beheading Holofernes*, c.1599 (Plate 15)

Caravaggio

Few artists have been so talked about in their lifetime or so quickly forgotten after their deaths as Michelangelo Merisi da Caravaggio (1571–1610, fig. 1). He was notorious both as a painter and as a person. While the novel way he utilized his skill spawned a race of imitators and followers, some of great distinction, his unbalanced behaviour ruined his career and alienated faithful supporters and friends. He became a meteor, dazzling but ultimately short-lived. By the early years of the twentieth century he was unknown except to a few learned men. One such scholar, Roberto Longhi, has brought him back to the attention of connoisseurs. Identifying a Caravaggio has become a thrill for dealers and a risk for scholars, yet exhibitions devoted to him have attracted many visitors. He has inspired a film by Derek Jarman, and one of the characters in Michael Ondaatje's *The English Patient* bears the name Caravaggio. Early secular works have led to discussion about his sexuality (fig. 2), his religious works are said to be perversely sadistic, he has been indicted as an unbeliever, even an assassin, in fact he is almost as controversial now as when he was alive. Set against the artificiality of so many of his contemporaries, he seems very natural.

Caravaggio's career was so short, lasting barely fifteen years, so restless, for he travelled all over Italy, so revolutionary, since he changed what was expected of art, and so influential, since many tried to copy him, that it is important to define what his naturalism meant. He was not like a nineteenth-century landscapist, forever painting in the fresh air; instead he had a love for gloomy cellars, lit usually by a single shaft of light high up on the wall to the left. Though he assured Giustiniani that 'it was as difficult for him to make a good painting of flowers as of figures', he did not rank botanical art above figurative art; indeed it seems likely that it was always his ambition to excel as a 'history' painter, that is to say, one who could dramatize Christian or classical scenes. To achieve this he had to master the representation of the human body and to have the knowledge to be able to refer to Renaissance pictures or classical statues – his aims were traditional. The novelty came in the execution.

Caravaggio is one of the few Italian painters who seemingly never used drawings. X-rays prove he repainted canvases, sometimes abandoning one subject for another, often substituting one detail for another, even altering a whole composition (in the case of *The Martyrdom of St Matthew*, Plate 16). The conclusion from available evidence is that he must have painted directly onto the canvas, but so sure was his judgement that he rarely made changes to his original ideas.

What makes Caravaggio unique is his handling of paint. On this topic one of his biographers, Bellori, is generous: 'Caravaggio's colours are prized wherever art is valued.' Bellori knew that in reacting against the artificiality of his Mannerist predecessors, Caravaggio avoided cinnabar reds and azure blues among his colours, or at least toned them down. He avoided a clear, blue atmosphere – nobody could know that he lived in the sun-drenched Italy which Raphael had inhabited – and used black in

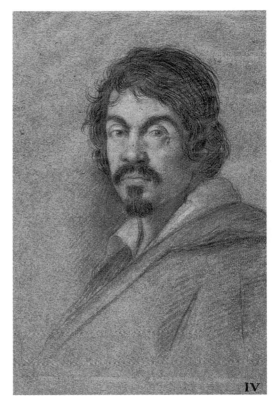

Fig. 1
OTTAVIO LEONI
Caravaggio
*c.*1621–5. Red and black chalk with white heightening on blue paper,
23.4 x 16.3 cm.
Biblioteca Marucelliana, Florence

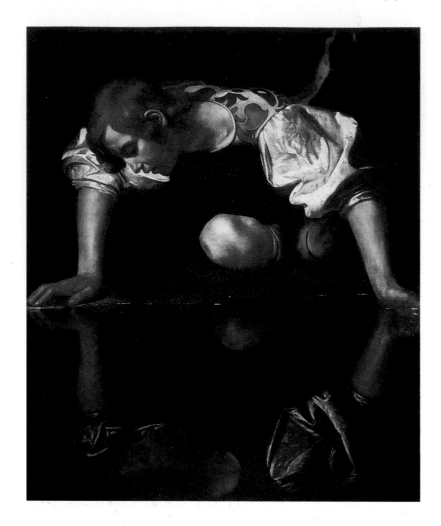

his grounds and black in his flesh tones. Up to the year 1600 he used light greens and warm reds, but gradually the dark browns and dark greens and black took over till in Sicily only white light shone in streaks through the darkness. Bellori writes almost like a modern critic in giving a subjective meaning to Caravaggio's choice of pigments. His style, he writes, 'corresponded to his physiognomy and appearance; he had a dark complexion and dark eyes, and his eyebrows and hair were black; this colouring was naturally reflected in his paintings. His first style, sweet and pure in colour, was his best; he made a great achievement in it and proved that he was a most excellent Lombard colourist. But afterward, driven by his own nature, he retreated to the dark style that is connected to his disturbed and contentious temperament.'

The appeal of Caravaggio may be above all psychological. His strange and tormented character fits Romantic preconceptions of the misunderstood artist: the nobler his paintings became the more violently he behaved, till murder was the logical outcome of a petty quarrel, and thereafter those who admired him found that he made it hard for them to help him. All his sins were mortal, he said, and yet few have painted more touching pictures of the grieving Magdalen, of Christ's call to Matthew the publican, of Christ's arrest in the garden, of Christ's appearance at Emmaus, of the deaths of the Virgin and of John the Baptist, or of David holding the head of Goliath with distaste. In his own pictures he sees himself without self-pity, he scrutinizes his own sick features as Bacchus, he leans back to watch while St Matthew is beheaded, he peers forwards in the garden of Gethsemane to catch what is happening to Christ. Not everything is disturbed or disturbing. There are many beautiful details – fruits and flowers in baskets and vases, fine brocade on dresses, fine musical instruments, fine carpets – and light

Fig. 3
ANNIBALE CARRACCI
Assumption of the
Blessed Virgin Mary
*c.*1600. Oil on wood,
245 x 155 cm.
Santa Maria del Popolo,
Rome

glistens on glass and catches the white hairs on a horse's back, or the bald head of an old man, or the glint of a sword flecked with blood. But his claustrophobic world, where blue is rare and colour flames red and orange or is muted in grey and fawn or turns sombre in dark green, dark brown and black, remains curiously compelling – he touches people over whom other artists less gauche, more even-tempered and less vulgar, have no power.

Before he came to Rome in 1592, he was used to checking ideas against experience; and that was why he put such store by the study of the model. His northern Italian education in the painting of fruits and flowers gave him a grounding in a concentrated observation of the life around him. When he added a central Italian understanding of perspective, he could paint musical instruments with a skill that links him to the Dutch painters who were to learn from his example: Hendrick ter Brugghen (1588–1629), Gerrit van Honthorst (1590–1656) and Dirck van Baburen (*c.*1595–1624). He could reproduce the reflections of light in mirrors and glass carafes in the manner befitting a contemporary of Galileo, whose masterly book on the telescope was published in 1609. But Caravaggio knew that without a knowledge of the human figure he

would never be considered, as he would put it, a *valentuomo*, a connoisseur of art. His first essays were awkward – he made a speciality of foreshortened shoulders that were too cramped – and he never acquired the facility that a disciple of Michelangelo or Raphael might take for granted. He found a way of making this very inelegance into an asset. His people would be sick or plump, scrawny, dirty, coarse or effete, but they would resemble passers-by in the street or drinkers in a tavern; they were not gods come down to earth. Over the years his males matured from the wistful adolescents of the 1590s to the tougher characters of the 1600s, and his females became wiser with age; indeed, it is usually the old women who are more sympathetic than the young Judiths or Salomes or Catherines (Plates 15, 40 and 14 respectively); and it is seldom, possibly only when resting on the Flight into Egypt (Plate 8) or as Madonna of the Pilgrims (Plate 31), that the mother of Jesus has the grace to be Our Lady. His subjects wore classical or modern clothes; occasionally, as in the St Matthew paintings, they wore both (see Plate 17, for example). There was no disguising the truth that all were playing roles. They react with startled looks, ungainly gestures, mouths open in screams or in song, hands reaching for their swords or clasping their knives. Whether vulnerable peasants or self-consciously fashionable, they are always spontaneous.

From many documents it is possible to reconstruct the history of Caravaggio the man and the painter, the better to understand his paintings. The official sources of his life are not the stuff of romance. There are the legal transactions, including contracts to paint and payment for work done (none of them before 1599), there are the comments of his patrons, the inventories of the collectors and there are the records that witness to his problems with the law. In addition there are seven accounts of his life, five Italian (by Mancini, Baglione, Scanelli, Bellori and Susinno) and two northern (by van Mander and von Sandrart). Though unlike modern biographies, some sketch his troublesome character and all provide valuable evidence of his paintings; indeed until recently they were used as the most reliable guide to identifying them. Giulio Mancini rose to be physician to Pope Urban VIII, whom Caravaggio had portrayed as young Monsignor Barberini (fig. 4). When he was writing his *Considerations on Painting* (*c*.1621), Mancini knew men who had been acquainted with Caravaggio. The other early writer, Giovanni Baglione, could reminisce from a more personal viewpoint. Baglione had been a rival of Caravaggio's and had taken him to court for libel before writing about him in the 1620s and publishing his story in 1642. Other Italians published much later. In 1657 Francesco Scanelli, from Forlì in the Romagna, digressed from analysing the four main schools of painting (Roman, Venetian, Lombard and Bolognese) to discuss Caravaggio as the key exponent of naturalism. Giovanni Pietro Bellori's *Lives of the Painters, Sculptors and Modern Architects* dates from 1672. This is by far the most distinguished and most detached history of the period, and although aesthetically hostile to Caravaggio, is still careful to place him in the context of the artistic achievement of the century. Meanwhile Caravaggio's fame had spread north of the Alps. As early as 1604, Karel van Mander in Haarlem had heard some inaccurate gossip about him – not having the first-hand knowledge of Rome that the German Joachim von Sandrart used to good effect in a thorough life of 1675 – but another record based on local information, the *Lives of Messinese Painters* by Francesco Susinno, is full of slander. Even in 1724 Caravaggio was a name to be recalled by a pious cleric with a shudder of disapproval.

Michelangelo, as his contemporaries called him, was born to Fermo Merisi and Lucia Aratori in Milan in the autumn of 1571, the oldest of

Fig. 4
Maffeo Barberini
c.1598–1600. Oil on canvas,124 x 90 cm.
Private collection, Florence

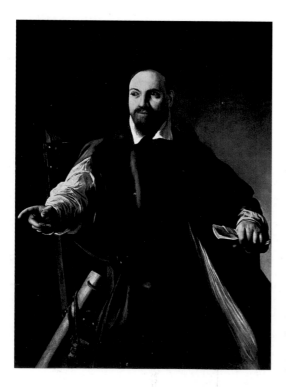

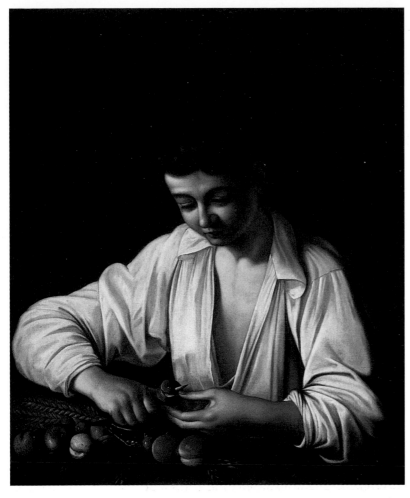

Fig. 5
Boy Peeling a Fruit
c.1593–94. Oil on canvas,
75.5 x 64.4 cm.
Private collection, Rome

four surviving children. Fermo worked as a builder for the local marchese of the small Lombard town of Caravaggio, midway between Cremona, Brescia and Bergamo, and, as he was favoured by the marchese, he acquired property in the area. It was to Caravaggio that he brought his young family back in 1576, probably to escape from the plague, but this did not save him from his own death the following year. The family was well educated. Fermo's brother Ludovico was a priest in Rome and Fermo's second son, Giovanni Battista, studied with the Jesuits before becoming subdeacon to the bishop of Bergamo in 1599. Michelangelo too must have learned basic literacy before he began to think of earning his keep. In 1584 he signed on as an apprentice to Simone Peterzano (*fl.* 1573–96), a relatively obscure Milanese painter, and stayed with him till 1588. For the next four years nothing is known of his career. His restless temperament and, if Mancini can be trusted, an early crime probably kept him on the move, gradually acquiring a sound knowledge of the art of the area. His Roman paintings show how aware he was of Northern Italian artistic traditions: that of Milan back to Leonardo (1452–1519) and Bernardino Luini (*c*.1481/2–1532) via minor artists like Peterzano and Antonio (1523–87) and Vincenzo Campi (1530/5–91); that of his home region back to Lorenzo Lotto (1480–1556/7), the self-exiled Venetian, via Moretto (*c*.1498–1554), Giovanni Battista Moroni (1520/4–78) and Giovanni Girolamo Savoldo (*fl.* 1508–48); and maybe that of Venice too. Bellori claims that he visited Venice, Roman critics thought he was familiar with the style of Giorgione (1477/8–*c*.1510) and, if he spent any time there, he must have come across works by Titian (*c*.1487/90–1576), Paolo Veronese (*c*.1528–88) and Tintoretto (1518–94). This is conjecture. Legal documents prove only that from 1589 to 1592 he was involved in the sale of land in Caravaggio. His mother died in 1590, the final division of

Fig. 6
The Fortune-Teller
*c.*1594–95. Oil on canvas,
115 x 150 cm.
Pinacoteca Capitolina,
Rome

property between her heirs was made in May 1592, and he took his 393 *lire imperiali* along the road to Rome.

Rome was not the most populous, the richest or the most powerful city in the country. Milan and Naples were international cities with their Spanish viceroys, Genoa financed the Spanish world, Florence was controlled by a banking family so grand that within a decade a king of France would court a Medici heiress, and Venice maintained a naval and imperial presence in the eastern Mediterranean – if she had lost Cyprus, she still held Crete. Ambitious Catholic artists, especially those who were born or became subjects of the King of Spain (Caravaggio was a subject by birth), could travel widely. Caravaggio opted for Rome. There may have been personal reasons for his choice. His master Peterzano had been to the city in 1585, his uncle Ludovico was already there, his brother would go there too: and so Caravaggio settled in Rome some time late in 1592 or early in 1593. It was by happy accident an excellent choice.

The great struggle between the papacy and the Holy Roman Empire had come to a climax in 1527, when Charles V sacked Rome brutally, leaving the city devastated and impoverished. By the time of Caravaggio's arrival, the papal court was still preoccupied with restoration, and although Sixtus V had done much before his death in 1590 to refashion Rome as the *caput mundi*, the capital of the world, there were still projects to be completed. Since Michelangelo's death in 1564 there were still many walls to decorate throughout the city, but only inferior painters and sculptors to carry out the work, men who were demoralized by the thought of his energy, subsisting on the inventiveness of the past, and who were masters only of a manner, excusing their own lack of originality by fighting for academic status.

As long as a painter could gain the ear of a discriminating patron, it was a wonderful moment for him to arrive in Rome. There were huge sections of fresco to be painted in the pope's cathedral church of St John Lateran in time for the jubilee year of 1600. In about 1595 Annibale Carracci (1560–1609), already known for his achievements in Bologna, came to fill the ceiling of the Galleria Farnese with light-hearted scenes of the loves of the gods. For modern art critics Annibale is the only contemporary of Caravaggio whose works deserve to be placed alongside his (fig. 3).

As the pope claimed to be successor to the apostles Peter and Paul, Rome had always been the spiritual capital of the Catholic world. In the

late sixteenth century, however, Protestant heretics saw Rome as the apocalyptic Babylon; and signs of doctrinal aberration and clerical corruption undermined the essential role of the papacy within the Christian Church. The Catholic Church's response to this was the Council of Trent, which was called by Paul III in 1545 and which sat intermittently for the following eighteen years. The resultant legislation laid the emphasis firmly on reaffirming the Church's control over the laity, by means of clerical reform and popular evangelization. New religious orders were created to raise standards – the Jesuits by training the senses, imagination, mind and will; the Oratorians of Philip Neri by their reverence for simplicity; and the Capuchin followers of St Francis by their imitation of the life of Jesus. Some Protestants had regarded religious images as forbidden, so old themes in Catholic art were renewed: devotion to Mary had been challenged, so it was intensified; the use of relics had been scorned – they were collected more assiduously; the cult of the saints was halted – their ecstasies and their martyrdoms alike were recorded with relish. *The Golden Legend*, a collection of stories surrounding the lives of the saints, was used as the basis for depictions such as that of St Catherine and her wheel (Plate 14). New themes were also stressed, like the gift of tears (in acts of penance) (see Plate 4, for example), the gift of kindness (in acts of charity; see Plate 35), and God's grace in ordinary objects (as in the bread and wine of the Mass). Late sixteenth-century Rome had the air of a city turning to a stricter way of life, and the Counter Reformation was to give work to many generations of artists, Caravaggio among them.

Caravaggio had to make his way by his wits. If he still had any part of his inheritance left he could have lived in moderate comfort for a year or so, but Caravaggio was never moderate. When he was taken in by a priest and fed on lettuce – he must have run out of money – he nicknamed his host 'Monsignor Insalata'. He painted pictures and tried to hawk them around, accompanied by a young Sicilian friend Minniti, and he may have painted portraits daily for a hack to sell, in an attempt to draw attention to himself. He succeeded in a painful way when he had to go to the Ospedale della Consolazione after he was kicked by a horse, but having recovered he made a point of giving the prior some of his work. He must have been relieved when an eminent painter, Giuseppe Cesari d'Arpino (1568–1640), who later became a *cavaliere* or knight, mended his fortunes by offering to employ him as an assistant; and then for a few months Caravaggio was given a room by a Monsignor Petrignano from Forlì. He could prove that he was worth his keep. He had developed a facility for producing small canvases, some demonstrating his dexterity as a painter of flowers and fruit (fig. 5) – Romans expected that any Lombard must be good at that – and others his ability to imagine self-contained dramas (fig. 6, for example); and a further group took a less than respectful attitude to the ancient gods, like Bacchus. Instead of using the services of beautiful models he liked to call in his neighbours off the street, and if there was nobody else to hand, he would use himself and a mirror. Bellori was offended that once Caravaggio took a gypsy and painted her telling a young man's fortune (see fig. 6), and that another time he painted a woman drying her hair and called her the *Penitent Magdalen* (Plate 4). For Bellori there was something both new and demeaning in the way that people could recognize the men and women and boys in Caravaggio's paintings: the courtesan Fillide Melandroni (fig. 7), who was celebrated in her own right, modelled for both *The Conversion of Mary Magdalen* (Plate 13) and the *St Catherine* (Plate 14). For Caravaggio there was value in authenticity. Every early discussion of his art, from van Mander to von Sandrart, roots his art in its relationship to nature. Bellori puts the point in a perceptive, if hostile way:

Fig. 7
Portrait of Fillide
(destroyed)
*c.*1598–9. Oil on canvas,
66 x 53 cm.
Formerly Kaiser Friedrich
Museum, Berlin

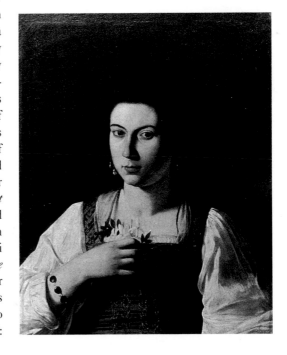

Fig. 8
Jupiter, Neptune and
Pluto
*c.*1599–1600. Oil on
plaster, 300 x 180 cm.
Villa Ludovisi, Rome

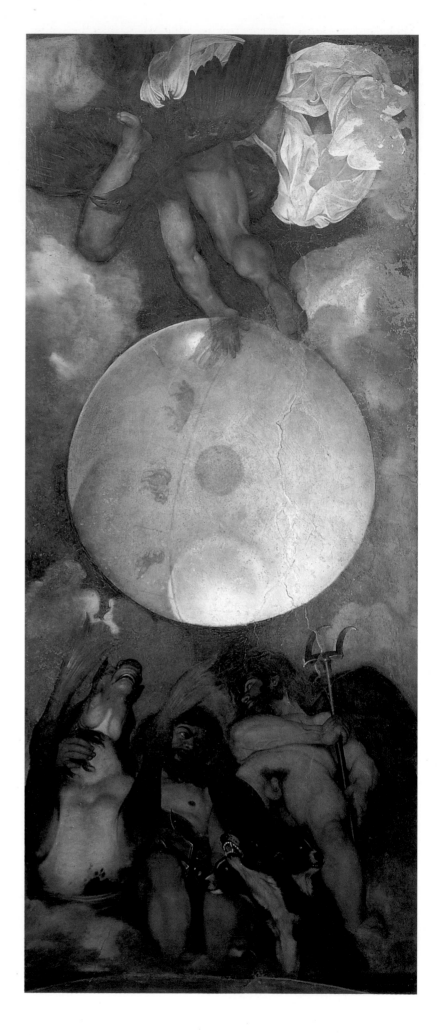

'Michelangelo Merisi … recognized no other master than the model, without selecting from the best forms of nature … He made no attempt to improve on the creations of nature.'

One of his happiest inventions, in which a young man is parted from his money by professional tricksters (Plate 5), came to the notice of Cardinal Francesco Del Monte. In 1595 he was invited to join the Cardinal's household in the Palazzo Madama, close to the Piazza Navona, and he probably stayed with del Monte for six years. As the man who discovered Caravaggio, Del Monte was his key patron; and their precise relationship has been closely scutinized. Recently art historians have asserted that a number of Caravaggio's works are homoerotic. Some have argued that Caravaggio was homosexual, others that he set out to gratify the tastes of Del Monte, and all have pointed to the paintings.

In a libel trial in 1603 Caravaggio was accused of having a boy lover. The charge was not pressed – it would have been serious for Caravaggio had it been true – and it is wise to assume that the remark was an insult. There is also one late and unreliable source that can be discarded. The evidence for Del Monte's supposed inclinations is equally suspect. In 1617, the Venetian ambassador described Del Monte as 'a living corpse … given up wholly to spiritual matters, perhaps so as to make up for the licence of his younger days'. When he first met Caravaggio, Del Monte was over forty-five – hardly in 'his younger days' – and was said to be a kindly, easy-going and cultivated man; and nobody has recorded what sins he had committed in his youth. Another document shows that in 1605 Del Monte attended entertainments at which boys danced dressed as women. Such behaviour was common all over Europe. In Shakespeare's Protestant England all the women's parts were played by boys, and when at the court of Charles I in the 1630s the French Queen Henrietta Maria appeared on the stage, the Puritan pamphleteers were appalled. Because the Cardinal was celibate, his household was largely male, and if Caravaggio found his models among his companions, as was indeed his custom, the Cardinal's servants and musicians offered an obvious choice – the swaggering 'bravi' in some of the early pictures may have been wearing the Del Monte livery.

This leaves the silent witness of the pictures themselves. Caravaggio did not change his style immediately upon moving into the Cardinal's palace. *The Boy with a Basket of Fruit* and *Bacchus* (Plates 3 and 10), both of which may be homo-erotic, date to the time when he assisted d'Arpino, and the later *Cupid* (Plate 22) was in fact bought not by Del Monte, but by the Marchese Giustiniani. By contrast, the early *Cardsharps* (Plate 5, the first Caravaggio work acquired by Del Monte) has no sexual significance and the *Penitent Magdalen* suggests that the artist was susceptible to pretty women in distress. As for the Cardinal, he loved paintings of all kinds, and the inventory drawn up at his death shows that over a lifetime he had amassed some 700 of them, and many were portraits. In the sixteenth century writers were fascinated by Ovid's tales of the hermaphrodite, of the boy Ganymede with whom Jupiter fell in love, and of the soft and self-indulgent Bacchus. Caravaggio knew these stories well and his eye fell on the young boys, some of them singers who would have been castrated (*castrati*), who might sit for him.

Music mattered almost as much to Del Monte as painting. He was a keen amateur musician and at his death left a roomful of instruments. As a young man he played the guitar and sang in the Spanish style, and in the 1590s Pedro Montojo, a young Spanish castrato, was living in his household – along with 200 other people. According to Baglione, *The Musicians* (Plate 6) was the first picture Caravaggio produced for Del

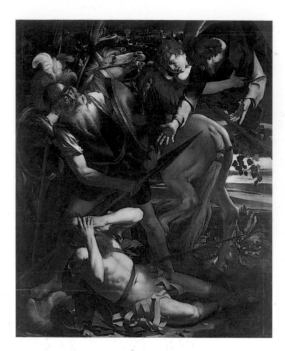

Fig. 9
The Conversion
of St Paul
1600–1. Oil on wood,
237 x 189 cm.
Private collection, Rome

Monte, and this was followed up in around 1596 with *The Lute-Player* (Plate 7). Nobody knows who modelled for the boys. Montojo may have been one of them, perhaps the soloist, but current theories of beauty praised hermaphrodites as having the best qualities of both sexes, so any bisexuality may have been a sign of the sophistication rather than the depravity of such pictures. The Cardinal's musical tastes were a little conservative, for the scores Caravaggio copied onto canvas in his palace were not taken from the recent motets of Palestrina, who had just died, or from the leading madrigal composer of the day, Marenzio, but from works by two composers of previous generations, Bauldewijn and Arcadelt. The Cardinal was conservative in another way: he observed the social proprieties by not keeping around him any women musicians, for this was Rome, not Venice.

For Del Monte's little pleasure house or *casino*, which was later sold to the Ludovisi family of Pope Gregory XV, Caravaggio executed his only mural, an oil on plaster picture of *Jupiter, Neptune and Pluto* (fig. 8). The Cardinal, says Bellori, 'was fascinated with chemical medicines and adorned the small room of his laboratory, associating those gods with the elements with the globe of the world placed in their midst'. If Caravaggio could represent Del Monte's interests for him, in return Del Monte could make a point of fostering his painter's career. Del Monte introduced his friends to Caravaggio's work and allowed him to paint for others. *The Rest on the Flight into Egypt* (Plate 8) must date from this period and seems to have no connection with Del Monte; and the same must be true of the destroyed portrait of the courtesan Fillide Melandroni (fig. 7), which was presumably commissioned by her protector, the Florentine nobleman Giulio Strozzi. Del Monte was generous to Caravaggio; indeed, if anything, he was too tolerant of the moods of his awkward guest. Later he had cause to apologize to the Duke of Modena: Caravaggio, he explained, was wildly eccentric (*un cervello stravagantissimo*, literally 'a very extravagant brain'); and yet in a moment of trouble, in October 1604, this eccentric had felt able to appeal to Del Monte for help. By then he was living on his own.

At some stage, probably in 1601, Caravaggio had taken himself off to the Palazzo Mattei, only a short walk away from the Palazzo Madama, and there he lived for two years, perhaps till shortly before the death of his new host in 1603. Cardinal Girolamo Mattei, Protector of the Observantine Franciscan friars, was the second of three brothers. Their senior in rank, he lived austerely in the vast Renaissance palace the family had inherited. At his death he owned only sixteen paintings, scarcely sufficient to cover the walls of his main rooms, and he left orders that no portrait of him, and no pomp, should mark his passing. His brothers Ciriaco and Asdrubale lived next door in a new palace built for Asdrubale by the future architect of St Peter's, Carlo Maderno, and there Asdrubale displayed his famous collection of antique sculptures and presumably the *St Sebastian* (now lost) that was painted for him by Caravaggio. Ciriaco was the most enthusiastic client of his brother's guest, for he paid for three works: *The Supper at Emmaus* (Plate 20), *The Betrayal of Christ* (Plate 26), and a third work, usually reckoned to be the *St John the Baptist*, patron saint of Ciriaco's eldest son Giovanni Battista (Plate 25).

The influence of Cardinal Mattei brought a more profound note to Caravaggio's art, for two of the scenes depicted are moments from Christ's Passion and Resurrection, the first when faith was shattered, the second when faith was remade. The discovery and testing of faith are themes that run through other paintings of this period, all of them made for other patrons: *The Conversion of St Paul* (Plate 18), which exists in two versions, one now in private hands (fig. 9); *The Death of the Virgin*

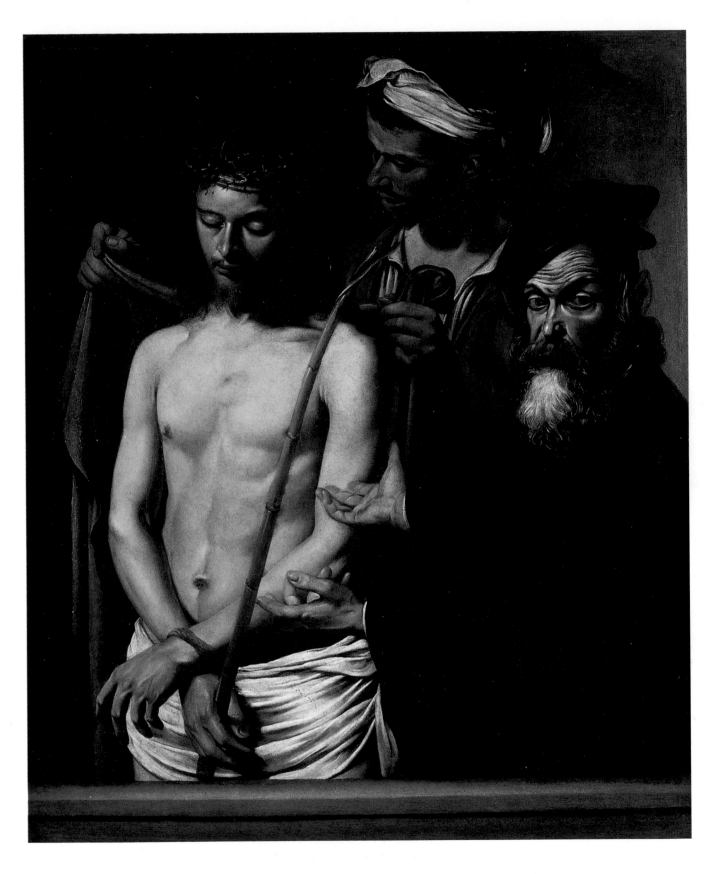

Fig. 10
Ecce Homo
c.1609. Oil on canvas,
128 x 103 cm.
Palazzo Rosso, Genoa

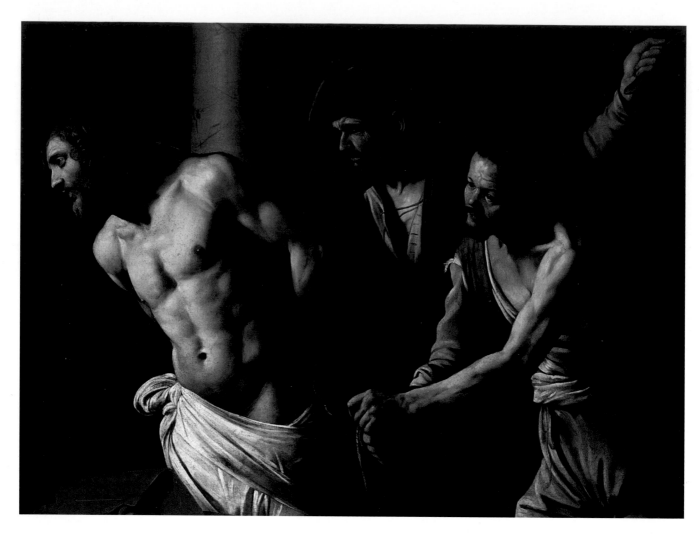

Fig. 11
Flagellation of Christ
*c.*1606–07. Oil on canvas,
134.5 x 175.5 cm.
Musée des Beaux-Arts,
Rouen

(Plate 23, for the church of Santa Maria della Scala); and the *Doubting Thomas* (Plate 27, for Marchese Vincenzo Giustiniani). The one important secular work to survive, the *Cupid* (Plate 22, also for Marchese Giustiniani), plays with forms from Michelangelo's Sistine ceiling, just like Mattei's *St John the Baptist*. This might appear to be a trivial device, were it not that Annibale Carracci was doing much the same in the Palazzo Farnese. What is more revealing, is that whilst some conventional clerics – those at San Luigi dei Francesi (see Plate 24) and at Santa Maria della Scala (see Plate 23) – found Caravaggio's art hard to take, noble patrons, whether religious or lay, competed for his favours.

Like a celebrity, he was spoiled and temperamental. Bellori tells how after spending a few hours of the day painting, Caravaggio would 'go out on the town with his sword at his side, like a professional swordsman'. From 1600 onwards he was familiar to the police and judges of Rome. He is first mentioned as intervening to stop a quarrel between his new friend, Onorio Longhi the architect (*c.*1569–1619), and a painter called Marco Tullio. Luckily he was so ill that he could scarcely stand up, let alone draw his sword from its scabbard. On subsequent occasions he was in better health. He was taken to court for slashing an enemy's cloak and giving a permanent scar to a guard from the Castel Sant'Angelo. In August 1603, shortly after his servant left him, he and Longhi, together with the painters Orazio Gentileschi (1563–1639) and Filippo Trisegni, were accused of libel by Giovanni Baglione (*c.*1566–1643), the painter who was to write Caravaggio's life. The court case shows up the small, tight-knit, envious world of the city painters. Baglione, who had just painted a *Resurrection* for the church of Il Gesù, claimed that he was being persecuted by his rivals, in particular by means of scurrilous verses that

some of them were privately circulating against him. The verses themselves have a schoolboy sense of humour, and most of the accused betrayed an adolescent willingness to blame each other. What Caravaggio's testimony reveals, however, is that he was alarmingly straightforward. He was not a man to win friends. Whereas Gentileschi put Caravaggio in the first group of painters and said that Caravaggio regarded him as a friend, Caravaggio said that Gentileschi had not been speaking to him for three years, and he did not rank Gentileschi among the distinguished artists. These, the *valentuomini*, included only the Cavaliere d'Arpino, who was no longer on good terms with him, Federico Zuccaro (*c*.1540/2–1609), Cristoforo Pomarancio (1552–1626) and Annibale Carracci. Under further examination he added to this short list Antonio Tempesta (1555–1630), but Baglione he did not take seriously ('I don't know about there being any painter who will praise Giovanni Baglione as being a good painter'). By a *valentuomo*, he meant a man who 'knows well how to paint and how to imitate natural things' and also one with 'a real understanding of painting', who 'will pronounce those to be good whom I have pronounced good and bad those I have pronounced bad'. Connoisseurship was thus put on a level with technical skill. Baglione counted on neither of these criteria, and indeed Caravaggio made it clear that he regarded him with contempt. If he himself was put in prison, it was because he was bad at winning friends among his equals, and if he did not stay there long, it was because he was good at influencing his superiors. The French ambassador intervened and in a fortnight Caravaggio was released.

For some time his French connections had been helpful. Del Monte was pro-French, and the Grand Duke of Tuscany, whom Del Monte represented, had pulled off a marriage between his niece and the King of France. Caravaggio had recently been painting in a chapel of the French church, San Luigi dei Francesi, and he was currently working on *The Sacrifice of Isaac* (Plate 29) for Maffeo Barberini (fig. 4), recently a bishop, who was named papal nuncio to France in 1604. Clement VIII, pope from 1592 to 1605, regarded his reconciliation with the French as the diplomatic triumph of his pontificate. In 1589, after thirty years of religious strife, the legitimate king of France was Henri IV, leader of the Protestants, so it seemed that France, oldest daughter of the Catholic Church, might secede from it. News was almost too good to be true when in 1593 Henri IV converted to Catholicism. The following year the Pope accepted the sincerity of this conversion. The Pope's vision of Christian concord was attainable; and in 1601 Philippe de Béthune arrived in Rome on an embassy to confirm that Henri IV's change of faith was genuine. This was the ambassador who in 1603 intervened on behalf of Caravaggio to regain him his freedom.

Caravaggio, no longer living with a cardinal protector, had moved a little way from the Palazzo Mattei to the quarter of San Biagio. He was confined to his house and told that without written permission he was not to leave it on pain of being made a galley-slave. For a while he behaved himself; when his friend Longhi was in trouble for insulting Baglione again in November, Caravaggio was not implicated. In January 1604 he was in Tolentino in the Marches with a commission for the Capuchin church, but nothing suggests that he fulfilled his contract and he was soon back in Rome to finish his much-admired *Entombment* (Plate 28). This work demonstrated that he was the true successor of Michelangelo and Raphael, a success which did nothing to curb his unruly temperament. He was arrested for throwing a plate of artichokes at a waiter, for throwing stones, and for abusing the police. In February 1605 he complained that he had been cheated of a rug worth 40 scudi, but it was not long before others were back in court to bring accusations

Fig. 12
Nativity with Saints
Francis & Lawrence
(stolen)
1609. Oil on canvas,
268 x 197 cm.
Formerly San Lorenzo,
Palermo

against him. He was arrested for carrying a sword and dagger without a licence and the officer was so struck by the weapons that he drew a sketch of them. Then Caravaggio was put in gaol for bothering a woman and her daughter and had to be bailed out by friends. Only nine days later he committed a more serious offence. In front of the palace of the Spanish ambassador he had drawn his sword on a lawyer, Pasqualoni, over Lena, a courtesan whose pitch was the Piazza Navona and whom the victim described as 'Caravaggio's woman'. At first Caravaggio had fled to Cardinal Del Monte's palace, but within a week he had left for Genoa no doubt under the protection of the rich Genoese in Rome who had been generous to him, especially Marchese Vincenzo Giustiniani and Ottavio Costa; and so Genoa possesses an *Ecce Homo* ascribed to Caravaggio (fig. 10).

Caravaggio did not stay long; the lure of Rome was too strong. In 1605 there arrived a new pope, Paul V, whose nephew Scipione Borghese had a boundless appetite for collecting paintings and a great indulgence towards a favourite painter, for within weeks of being appointed Cardinal he had arranged for Caravaggio to make peace with the lawyer he had assaulted and had him released from gaol yet again. Caravaggio must have expected preferment at the highest level, for Bellori says that he painted a portrait of the Pope, and the Cardinal set about acquiring as many of his works as he could, even going so far as to force the Cavaliere d'Arpino to disgorge some, on the grounds that he was in arrears with the payment of taxes. And yet within a week a former landlady complained that Caravaggio owed her six months' rent and had thrown stones at her window shutter and broken it. Throughout the autumn he was being paid by the agent of the Duke of Modena for a picture which had not been delivered; then it was said he was resting in the house of Andrea Ruffetti to recover from stab wounds to the throat and left ear which he claimed were self-inflicted. This may have been the moment when he painted an austere *St Jerome* (Plate 33), which must have seemed curiously inappropriate in the hedonistic setting of the Borghese villa. What is certain is that by 8 April 1606 he had received 75 scudi for the *Madonna dei Palafrenieri* (Plate 32; the *palafrenieri* were the papal grooms), and that nine weeks later the painting had been bought by the Pope's nephew for 100 scudi. By then Caravaggio had left Rome for good.

The self-destructive course of his career reached its climax at the end of May. Baglione, who must have been well-informed, tells how he quarrelled over a tennis match with 'a very polite young man', Ranuccio Tomassoni of Terni. Caravaggio, according to the police report, had lost a bet of 10 scudi, the argument had turned into a fight, swords were drawn and in the mêlée Caravaggio wounded his opponent in the thigh and killed him. Onorio Longhi, who had been the aggressor the first time that Caravaggio had been up before the police, was inevitably present on this last occasion, and although he spoke on oath as an innocent witness, he took the precaution of seeking refuge in Milan before begging to be allowed to return for the sake of his wife and children. As a man guilty of a capital crime, Caravaggio was in a much more serious situation. He could no longer rely on the good will of Scipio Borghese and in spite of his wounds, he also took flight, leaving the Duke of Modena's painting unfinished. In the midst of this crisis, as so often in the past, he found a protector. Among the noble families of Rome, none was the equal of the Colonna. Though probably surpassed in wealth by recent papal relatives, the Colonna behaved as if they were independent princes; and while Caravaggio sheltered that September on the estates of Duke Marzio Colonna at Zagarolo, near Palestrina, he could feel safe. He continued to paint. Baglione and Bellori refer to a

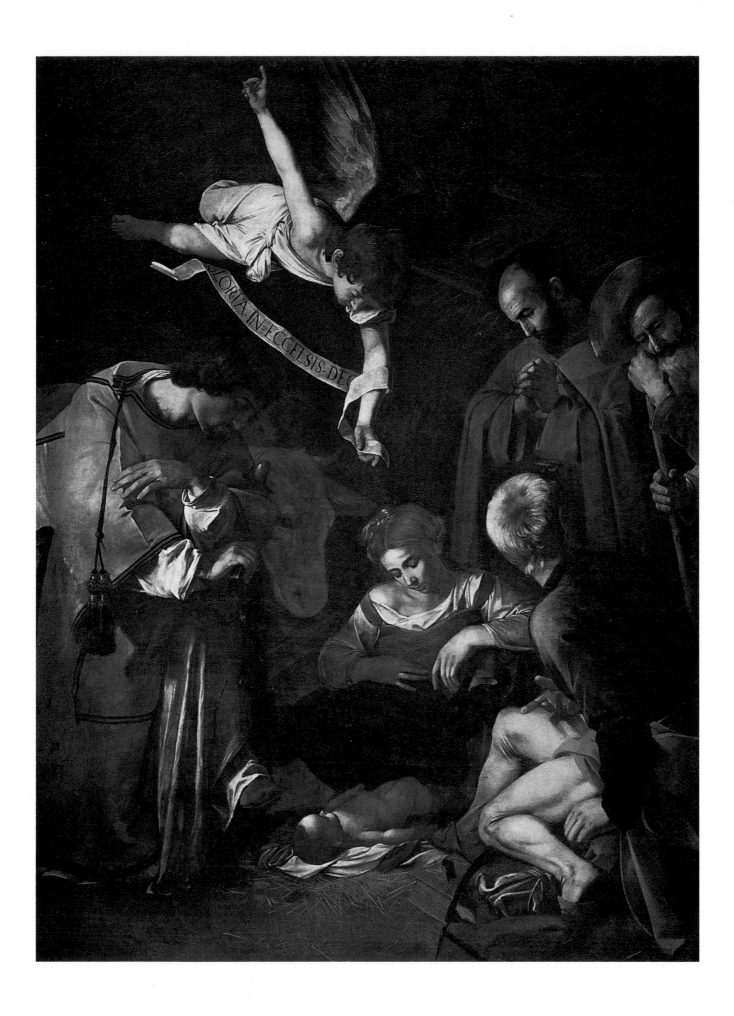

GLORIA IN ECCELSIS DE

Mary Magdalen in Ecstasy, and Bellori also mentions a *Supper at Emmaus*. Caravaggio maintained links with his Roman patrons, for the second painting, probably the one in the Brera gallery in Milan (Plate 34), was bought in Rome by Ottavio Costa. By 6 October, however, he had moved beyond the reach of papal justice. He was in Naples.

There, as in his youth, he was back in the dominions of the king of Spain. On 6 October he signed a contract to paint a Madonna and Child with a chorus of angels for a merchant named Niccolò Radolovich. He received 200 scudi, but whether he ever produced anything in return for the money is not known. On 9 January 1607 he fared even better, receiving the final instalment of 400 scudi for a monumental painting for the charitable organization of the Pio Monte della Misericordia, the *Seven Works of Mercy* (Plate 35). In size, if not quite in scale – *The Death of the Virgin* (Plate 23) has fewer and larger figures – it was the grandest picture he had ever painted and one of the most influential, for his vast canvas, legible in a darkened church only by the flickering light of candles, gave rise to a new Neapolitan style. A mood of acute pain informs the only other picture for which there is documentary evidence: *The Flagellation of Christ* (Plate 37) commissioned for San Domenico Maggiore (he was paid 440 ducats in the course of May). As the painting for Radolovich was to have included the friars' founding fathers, Saints Dominic and Francis, it is reasonable to suppose that Caravaggio's art was attractive to popular preachers in Naples, as had been the case in Rome. So credible was the image of the suffering Christ and his brutal tormentors that it could be an admirable text for a sermon, and he painted alternative versions for others (fig. 11).

By mid-July he was in Malta. The island was unique in Catholic Christendom, being a sovereign state presided over by a religious fraternity that had been set up for the care of the sick, but which had become the senior order of chivalry. Caravaggio had connections which it seems he used. Several Giustiniani relations were Maltese knights and his other Romano-Genoese patron, Ottavio Costa, was related to the knight Ippolito Malaspina; and it is the Malaspina coat of arms that adorns the door frame in the corner of a *St Jerome* (Plate 38) possibly projected in Naples, where Malaspina was Prior, before it was completed in Malta. Caravaggio was probably already known to the Grand Master – Alof de Wignacourt, a Frenchman who had taken part in the defence of Malta against the Turks as long ago as 1565–6. It seems likely that one of these patrons organized a deal whereby Caravaggio could become a knight and thus escape papal jurisdiction. Caravaggio, in turn, ratified the deal by painting two portraits of Wignacourt (one illustrated as Plate 39). On 14 July Malta rewarded its own painter with the rank of a brother and knight of obedience. Caravaggio responded with his most tragic painting, a huge altarpiece for Valletta cathedral representing *The Beheading of St John the Baptist* (Plate 40), the Order's patron saint. The artist was triumphant; he had social standing, two slaves and a rich collar of gold, and nobody spoke about his problems with the Pope. His nature ensured that his good fortune would not last.

He crossed a fellow knight and was imprisoned. Though his cell towered over the harbour, he somehow managed to escape by night and to flee to Sicily by boat, no doubt with the help, once again, of his influential friends. At a solemn hearing brothers Joannes Honoret and Blasius Suarez were charged with his recapture. Six weeks later proceedings were initiated to deprive him of his habit and on 1 December 1608 he was expelled from the Order and 'thrust forth like a rotten and fetid limb'. Most of the while he was in Syracuse, where his old friend Minniti had persuaded the Senate to commission a painting from him, and on 6 December in Messina he concluded an agreement

with another healing order, the Padri Crociferi, to paint a *Raising of Lazarus* (Plate 43) for the sum of 1,000 scudi, a huge amount. He must have thought that he was finally free of worry because he stayed in Messina at least till midsummer. His reputation for eccentric behaviour there was noted down in 1724 by the local historian Francesco Susinno. When some local worthies began to make observations about the picture, Caravaggio drew his dagger, 'which he always kept at his side', and began to slash the canvas. He coolly explained that he would soon paint another picture for them that would be even more beautiful. He was erratic in small matters – he would eat his food off an old canvas – and in great – when challenged for sketching boys at play he wounded their teacher on the head. The most revealing incident occurred in the doorway of a church. He was offered holy water by a gentleman who murmured that it would cancel his venial sins. 'It's not relevant,' cried Caravaggio, 'because mine are all mortal.'

He must have spent part of the summer in Palermo where he painted a *Nativity* (fig. 12), before taking the burden of his character with him back to Naples, where, according to the news in Rome on 24 October 1609, he had been killed in a brawl outside the Taverna del Cerriglio. In fact he had survived, but he had been badly disfigured; and still in Naples, he produced two further pictures (fig. 13 and Plate 47). He pressed on towards Rome. Cardinal Ferdinando Gonzaga, whose ducal brother owned *The Death of the Virgin*, had successfully petitioned the Pope for a pardon. The boat in which Caravaggio was travelling put into Palo just north of the papal states. The local authorities did not realize who he was and he was arrested by mistake and held in prison. When after two days he was let out, the captain had sailed away with all his belongings, and under the blazing sun Caravaggio ran along the shore to try to catch sight of his disappearing worldly goods. Traversing that notoriously malarial coast towards Porto Ercole he fell ill with a fever and in a few days, on 18 July, 'without the aid of God or man', he died. The Roman news bulletin referred to his fame as a painter and the indulgence of His Holiness; the knights of Malta refused to acknowledge him as one of theirs, but the viceroy of Naples was glad to claim his goods, 'especially the painting of St John'. Marino, foremost poet of the day, penned a lament in Italian, and a lawyer, Marzio Milesi, wrote a Latin epitaph in which he called Caravaggio 'in painting not equal to a painter but to nature itself' – he dedicated his words 'to a friend of extraordinary genius'.

The last few years of Caravaggio's short life were frantic. In terms of contemporary psychological theory he was a 'choleric' man, quick, assertive and impatient. With such a temperament, it was inevitable that he could only work with speed. Critics used to think that he never painted the same subject twice, so that if two or three near-identical paintings survive, either one is original and the others are copies or none are originals. But to prefer the London *Boy Bitten by a Lizard* to its Florentine counterpart is unproductive, for both look like autograph works, though no pictures are signed with the exception of *The Beheading of St John the Baptist* in Valletta. What seems true as a rule is that Caravaggio came to paint with ever-increasing fluency. He put marks on the canvas to place the angle of the head and plotted the face in relation to the ears. On some occasions he used geometry to plan his compositions, most visible in the church where St Matthew is martyred (Plate 16), the slab under which Christ will be entombed (Plate 28), the table at which He sits (Plate 34), and the bed on which His mother lies dead (Plate 23). Characteristically actions occur in front of blank walls or in an undefined space. His use of directional lighting and the penumbra of enveloping darkness mean that he can hide some defects: the

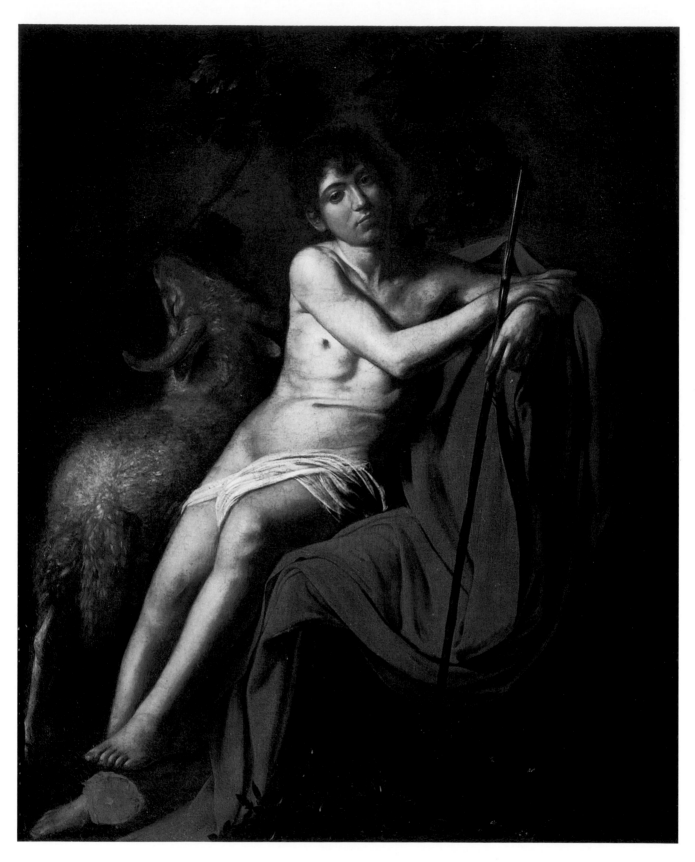

Fig. 13
St John the Baptist
*c.*1610. Oil on canvas,
159 x 124 cm.
Galleria Borghese, Rome

confusion of limbs, armour and clothing at the foot of *The Conversion of St Paul* (Plate 18), the crowding of the figures in *The Seven Works of Mercy* (Plate 35), the shifts of scale in *The Burial of St Lucy* (Plate 42). His art seems so spontaneous that lapses in execution are often overlooked. While in 1608–10 he was hurrying from one place to another, he may have dispensed with models. He left canvases unfinished, did not have time to be careful and had to rely purely on the strength of his technique.

During the seventeenth century he was attacked principally for his lapses in taste. The clerics who rejected the first *St Matthew* in the Contarelli chapel (see fig. 31), the pictures for Santa Maria del Popolo (in the first versions; see Plates 18 and 19) and *The Death of the Virgin* (Plate 23) were supported by the critics who took offence at the 'pretended' *Magdalen* (Plate 4), at the dirty feet of the pilgrims who pray to the *Madonna di Loretto* (Plate 31) and at the ugly *Madonna dei Palafrenieri* with her naked Christ Child (Plate 32). Bellori goes so far as to say that Caravaggio 'suppressed the dignity of art', yet it is for this very reason that he appealed to the sophisticated patrons who bought his works, that he won so many followers in the period 1600–50, and that he has gained once more in popularity since 1950. Few makers of sacred images have done so well out of being considered an iconoclast. This unorthodox achievement gives him an originality which is as startling in our day as it was in his.

Outline Biography

1571 4 January: Fermo Merisi married the twenty-one year old Lucia Aratori in a country church near the small town of Caravaggio. Their eldest son Michelangelo was born in Milan, probably in October.

1576 Living in Caravaggio.

1584 6 April: apprenticed in Milan to Simone Peterzano for a four-year term.

1589 25 September: Michelangelo starts process of selling off family land.

1592 11 May: family property is divided between Michelangelo, his brother Giovanni Battista, and their sister Caterina. Michelangelo goes to Rome, about the same time as his brother, now a priest, and is briefly housed by Monsignor Pandolfo Pucci of Recanati.

1593–4 Works with his friend, the Syracusan Mario Minniti.
In the Ospedale della Consolazione after being kicked by a horse – he gives the prior some paintings.
Works as a still life painter for Giuseppe Cesari (il Cavaliere d'Arpino).
Moves into house of Monsignor Petrignani.

c.1595 Invited by Cardinal Francesco Maria Del Monte to live in Palazzo Madama.

1596 20 November: Del Monte acquires the Casino dell'Aurora.
Sometime after December Caravaggio paints *Jupiter, Neptune and Pluto* there.

1599 23 July: contracted to paint side paintings in the Contarelli chapel, San Luigi dei Francesi.

c.1600 Parts company with Minniti and becomes a close friend of Onorio Longhi, a quarrelsome architect.

1600 4 July: acknowledges payment for the Contarelli paintings.
24 September: commissioned by Monsignor Tommaso Cerasi to paint in family chapel of Santa Maria del Popolo.
25 October: first mentioned in police records (with Onorio Longhi).
19 November: accused of assault.

1601 7 February: accused of assault.
10 November: paid for Cerasi paintings.

1602–3 Paints two versions of *St Matthew and the Angel*. Living in the Palazzo Mattei.

1603 By 3 January: paid for three paintings ordered by Ciriaco Mattei.
Paid for *The Sacrifice of Isaac* by agents of Maffeo Barberini.
28 August: accused of libel by Baglione.
11–25 September: in prison in Tor di Nona, till released through the efforts of the French ambassador.

1604 2 January: painting in Tolentino.
After 3 April Caravaggio competes against Cigoli to produce an *Ecce Homo*.
24 April: defendant in a case of assault.
6 September: *The Entombment* completed and probably in place.
20 October: arrested, sends to Cardinal Del Monte for help.
18 November: arrested and gaoled.

1605 15 February, 28 May, 20 July, 29 July: in further trouble with the law.
6 August: in Genoa.
26 August: released from gaol, thanks to Cardinal Scipione Borghese.
1 September: in trouble with the law.
October, November and December: paid by the Duke of Modena's agent.
24 October: recovering from wounds in the house of Andrea Ruffetti.

1606 13 May: receives final payment for *Madonna dei Palafrenieri*.
29 May: Caravaggio kills Ranuccio Tomassoni in a duel.
31 May: reported to be in flight towards Florence.
Spends summer in Sabine and Alban Hill estates of Don Marzio Colonna.
6 October: contracted in Naples to paint a *Madonna, Child and Angels*.

1607 9 January: paid 400 ducats for the *Seven Works of Mercy*.
17 February: Rubens begins negotiations to acquire the *Death of the Virgin* for the Duke of Mantua.
11 and 29 May: receives two payments of 440 ducats from Tommaso de' Franchis for *The Flagellation of Christ* for San Domenico, Naples.

13 and 26 July: Caravaggio a witness
in a legal case in Naples.
15 and 25 September: the painter
François Pourbus, in Naples, tells his
patron, the Duke of Mantua, that the
Madonna of the Rosary could be bought for
400 scudi and a *Judith* by Caravaggio for
300 ducats.

1608 14 July: becomes a knight of St John
of Malta, but shortly after is gaoled for a
quarrel with a noble.
6 October: escapes from gaol and flees
to Syracuse.
1 November, 6 December: expelled
from the knights of Malta.

1609 10 June: paid 1000 scudi for *The
Raising of Lazarus*.
Before August enters contract in Messina
with Niccolò di Giacomo for 4 paintings
of scenes of the Passion, including an *Ecce
Homo* already complete.
During August-September probably in
Palermo.
On October 24: wounded in a brawl in
Naples.

1610 11 May: Caravaggio said to have
painted a *Martyrdom of St Ursula*.
18 July: he dies in Porto Ercole.

Select Bibliography

General

L. von Pastor, *History of the Popes*, vols. 23–6, London, 1933 and 1937

Rudolf Wittkower, *Art and Architecture in Italy*, 1600–1750, London, 1973

Benedict Nicolson, *The International Caravaggesque Movement*, Oxford, 1979

Francis Haskell, *Patrons and Painters: Art and Society in Baroque Italy*, New Haven and London, 1980

Francis Haskell & Nicholas Penny, *Taste and the Antique*, New Haven and London, 1981

R. Ward Bissell, *Orazio Gentileschi and the Poetic Tradition in Caravaggesque Painting*, Pennsylvania, 1981

Rozsika Parker and Griselda Pollock, *Old Mistresses: Women, Art and Ideology*, London, 1981

Painting in Naples from Caravaggio to Giordano, exhibition catalogue, Royal Academy of Arts, London, 1982

S. J. Freedberg, *Circa 1600: A Revolution in Style in Italian Painting*, Cambridge, 1983

The Age of Caravaggio, exhibition catalogue, Metropolitan Museum of Art, New York, 1985

Eric Cochrane, *Italy 1530–1630*, London, 1988

Caravaggio

Roger Hinks, *Michelangelo Merisi da Caravaggio*, London, 1953

Walter Friedländer, *Caravaggio Studies*, Princeton, 1955; rev. edn. New York, 1969

Michael Kitson, *The Complete Paintings of Caravaggio*, New York, 1969; London, 1986

Homan Potterton, *The Supper at Emmaus by Caravaggio*, exhibition catalogue, National Gallery, London, 1975

Alfred Moir, *Caravaggio and His Copyists*, New York, 1976

Howard Hibbard, *Caravaggio*, New York, 1983

Alfred Moir, *Caravaggio*, New York, 1982; London, 1989

Sergio Benedetti, *Caravaggio: The Master Revealed*, exhibition catalogue, National Gallery of Ireland, Dublin, 1993

Creighton E. Gilbert, *Caravaggio and his Two Cardinals*, Pennsylvania, 1995

Catherine Puglisi, *Caravaggio*, London, 1998

List of Illustrations

Colour Plates

1 Self-Portrait as Bacchus
 c.1593–4. Oil on canvas, 66 x 52 cm.
 Galleria Borghese, Rome

2 Boy Bitten by a Lizard
 c.1593–4. Oil on canvas, 65.8 x 39.5 cm.
 National Gallery, London

3 Boy with a Basket of Fruit
 c.1593–4. Oil on canvas, 70 x 67 cm.
 Galleria Borghese, Rome

4 Penitent Magdalen
 c.1593–4. Oil on canvas, 106 x 97 cm.
 Galleria Doria Pamphilj, Rome

5 The Cardsharps (I Bari)
 c.1594–5. Oil on canvas, 94.2 x 130.9 cm.
 Kimbell Art Museum, Fort Worth

6 The Musicians
 c.1595. Oil on canvas, 92 x 118.5 cm.
 Metropolitan Museum of Art, New York

7 The Lute-Player
 c.1595–6. Oil on canvas, 94 x 119 cm.
 The Hermitage, St Petersburg

8 The Rest on the Flight into Egypt
 c.1595. Oil on canvas, 130 x 160 cm.
 Galleria Doria Pamphilj, Rome

9 St Francis in Ecstasy
 c.1596. Oil on canvas, 92.5 x 128.4 cm.
 Wadsworth Atheneum, Hartford

10 Bacchus
 c.1597. Oil on canvas, 95 x 98 cm.
 Galleria degli Uffizi, Florence

11 Medusa
 c.1598. Oil on canvas over convex wooden
 shield, 60 x 55 cm.
 Galleria degli Uffizi, Florence

12 The Fortune-Teller
 c.1598–9. Oil on canvas, 99 x 131 cm.
 Musée du Louvre, Paris

13 The Conversion of Mary Magdalen
 c.1598–9. Oil on canvas, 97.8 x 132.7 cm.
 Institute of Fine Arts, Detroit

14 St Catherine of Alexandria
 c.1599. Oil on canvas, 173 x 133 cm.
 Fundación Colección Thyssen-Bornemisza,
 Madrid

15 Judith Beheading Holofernes
 c.1599. Oil on canvas, 144 x 195 cm.
 Palazzo Barberini, Rome

16 The Martyrdom of St Matthew
 1599–1600. Oil on canvas, 323 x 343 cm.
 San Luigi dei Francesi, Rome

17 The Calling of St Matthew
 1599–1600. 322 x 340 cm.
 San Luigi dei Francesi, Rome

18 The Conversion of St Paul
 1600–1. Oil on canvas, 230 x 175 cm.
 Santa Maria del Popolo, Rome

19 The Crucifixion of St Peter
 1600–1. Oil on canvas, 230 x 175 cm.
 Santa Maria del Popolo, Rome

20 Supper at Emmaus
 1601. Oil on canvas, 139 x 195 cm.
 National Gallery, London

21 Still Life with a Basket of Fruit
 c.1601. Oil on canvas, 31 x 47 cm.
 Pinacoteca Ambrosiana, Milan

22 Cupid
 c.1601–2. Oil on canvas, 154 x 110 cm.
 Staatliche Museen, Berlin

23 Death of the Virgin
 c.1601–3. Oil on canvas, 369 x 245 cm.
 Musée du Louvre, Paris

24 St Matthew and the Angel
 1602–3. Oil on canvas, 296.5 x 189 cm.
 San Luigi dei Francesi, Rome

25 St John the Baptist
 c.1602. Oil on canvas, 129 x 94 cm.
 Galleria Capitolina, Rome

26 The Betrayal of Christ
 1602–3. Oil on canvas, 133.5 x 169 cm.
 National Gallery of Ireland, Dublin

1

Self-Portrait as Bacchus

*c.*1593–4. Oil on canvas, 66 x 52 cm. Galleria Borghese, Rome

Among Caravaggio's early works, this painting, in which the pose of the arm may recall his debt to the kneeling shepherd in a fresco by Peterzano (fig. 14), belongs to the small group which has always been seen as self-portraits. The livid colours of the subject's face, his teasing smile and the mock seriousness of his mythological dignity all reinforce the attempt to undermine the lofty pretensions of Renaissance artistic traditions. Here is no god, just a sickly young man who may be suffering from the after-effects of a hangover. There is no mistaking the artist's delight in the depiction of the fine peaches and black grapes on the slab, the white grapes in his hand and the vine leaves that crown his hair, but the artist is not content merely to demonstrate his superb technique: he wishes to play an intimate role and only the slab separates him from the viewer. His appearance is striking rather than handsome: he shows both that his face is unhealthy and that his right shoulder is not that of a bronzed Adonis, as convention required, but pale as in the case of any man who normally wears clothes.

Fig. 14
SIMONE PETERZANO
Adoration of the
Shepherds
*c.*1578–82. Fresco.
Certosa, Garegnano
(Milan)

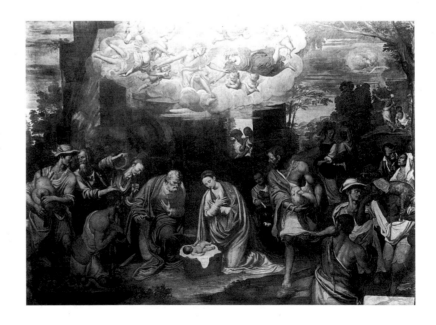

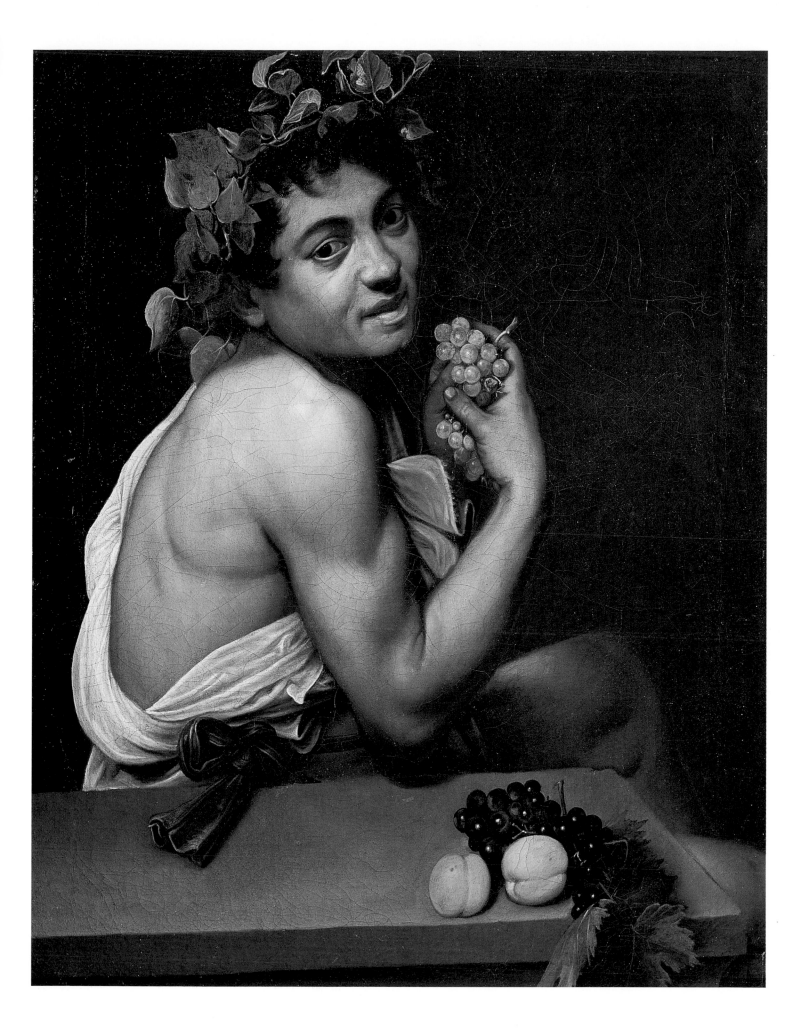

2 Boy Bitten by a Lizard

*c.*1593–4. Oil on canvas, 65.8 x 39.5 cm. National Gallery, London

This picture is wrongly said by Mancini not to be one of Caravaggio's earliest pictures, and since he also states that the picture was sold for less than Caravaggio expected, it must have been painted as a speculative venture.

One of the most effeminate of his boy models, with a rose in his hair, starts back in pain as his right-hand middle finger, which he has put into a cluster of fruit, is bitten by a lizard. The rose behind the ear, the cherries, the third finger and the lizard probably have sexual significance – the boy becomes aware, with a shock, of the pains of physical love. What was novel was not the theme so much as its dramatic treatment, evident in the boy's foreshortened right shoulder, the contrasting gestures of his hands and the leftward sloping light. What lingers most in the memory is found in the foreground: the gleaming glass carafe containing a single overblown rose in water, together with its reflections.

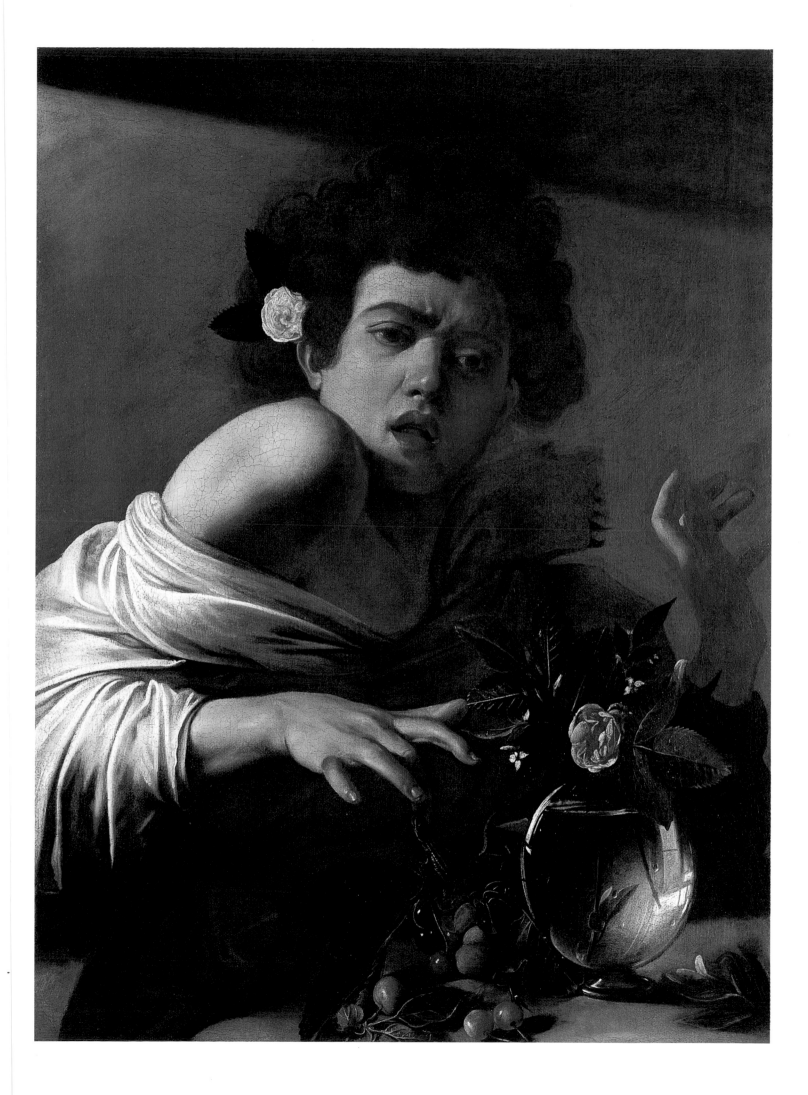

Penitent Magdalen

*c.*1593–4. Oil on canvas, 106 x 97 cm. Galleria Doria Pamphilj, Rome

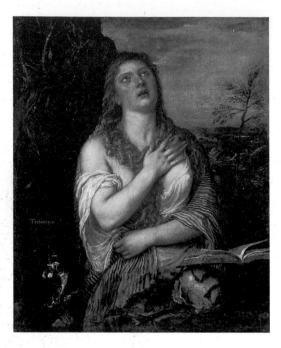

Fig. 16
TITIAN
Penitent Magdalen
*c.*1565. Oil on canvas,
118 x 97 cm.
The Hermitage,
St Petersburg

This picture and *The Rest on the Flight into Egypt* (Plate 8) must have been painted around the same time, for the same girl sat for the Magdalen and the Madonna. On this occasion, however, there are none of the usual signs of a religious scene such as a halo. A young girl, seen from above, is seated on a low stool in one of Caravaggio's favourite cave-like settings, with a triangle of light high up on the wall behind her. Discarded jewellery – a string of pearls, clasps, a jar (perhaps holding precious ointment) – lies on the floor. The girl's hair is loose, as if it has just been washed. Her costume, consisting of a white-sleeved blouse, a yellow tunic and a flowery skirt, is rich. Bellori, who gives a careful description of this picture, which he came across in the collection of Prince Pamphilj, regards its title as an excuse; for him it is just a naturalistic portrayal of a pretty girl. This seems to show a wilful failure to understand Caravaggio's intention or the wishes of the man who commissioned it, Monsignor Petrignani. The repentant Mary Magdalen, like the repentant Peter, was a favourite subject of Counter-Reformation art and poetry, which valued the visible expression of the state of contrition – 'the gift of tears'. Caravaggio's heroine is sobbing silently to herself and a single tear falls down her cheek. She is, as it were, poised between her past life of luxury and the simple life she will embrace as one of Christ's most faithful followers. It is a sign of the painter's skill that he makes this inner conflict moving at the same time as he makes its representation delectable.

Although nothing painted in the sixteenth century is as emotive as the statue in wood of the haggard saint carved by Donatello (*c.*1456–60), by the time Titian's bare-breasted *Magdalen* of the 1530s (Palazzo Pitti, Florence) had become the more modest and affecting *Magdalen* of the 1560s (fig. 16), there had been a move in religious sensibility towards the humble and pathetic, a change which thirty years later Caravaggio could take for granted.

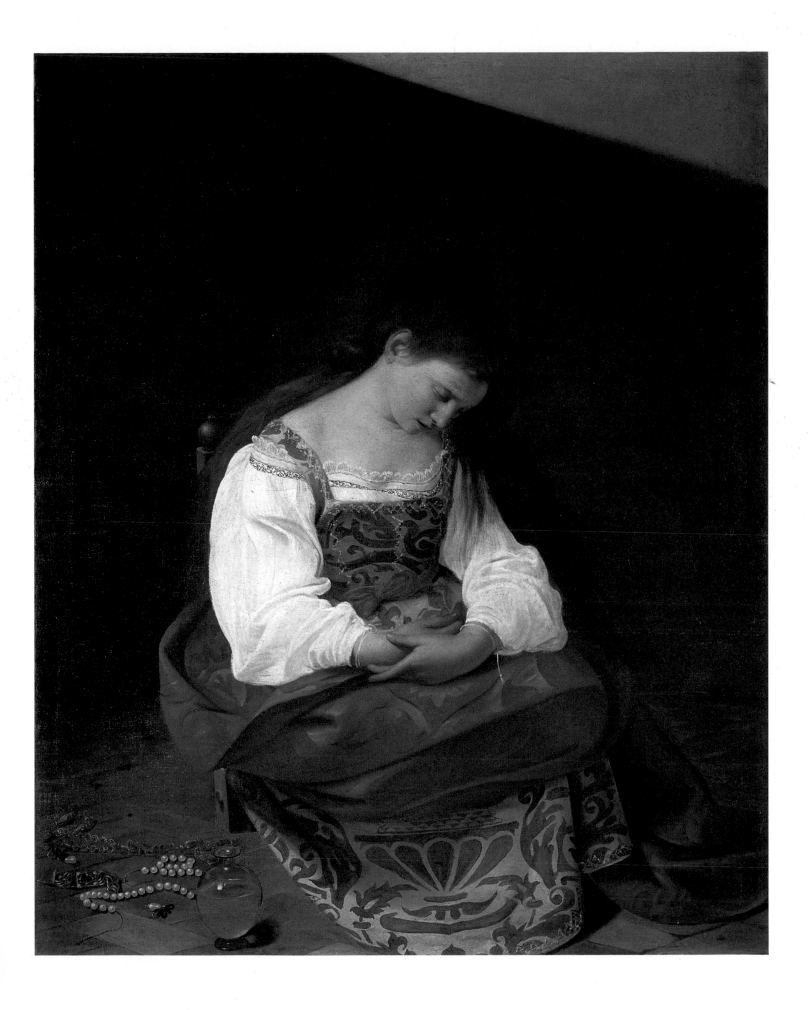

The Cardsharps (I Bari)

c.1594–5. Oil on canvas, 94.2 x 130.9 cm. Kimbell Art Museum, Fort Worth

The Cardsharps, lost for almost a century, has been found and is now in Texas, and helps to fill in an important stage in the development of Caravaggio's art. Behind a table that protrudes into the spectator's space, a youthful innocent studies his cards, overlooked by a sinister middle-aged man, whose fingers signal to another, younger scoundrel to his right, who holds a five of hearts behind his back. To the left-hand side of the canvas is the object of their conspiracy, a pile of coins.

This low-life scene links Caravaggio's discreet dramas to the genre paintings favoured by his followers. It was to have many imitators – within a few years of the painter's death an early variant had been painted by the Franco-Roman Valentin de Boulogne (fig. 17) – but few equals. Caravaggio was less melodramatic than many of the artists known as the *Caravaggisti* who painted in his style, and he suggests only enough of the interaction between the three actors to imply the sequel.

Fig. 17
VALENTIN DE
BOULOGNE
The Cardsharps
c.1615–18. Oil on canvas,
94 x 137 cm.
Gemäldegalerie, Dresden

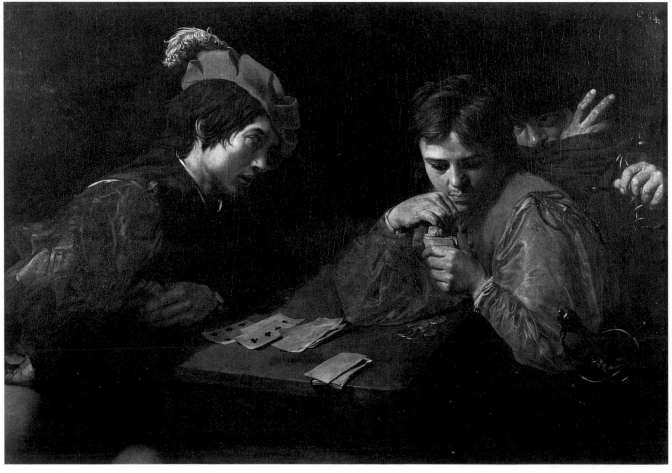

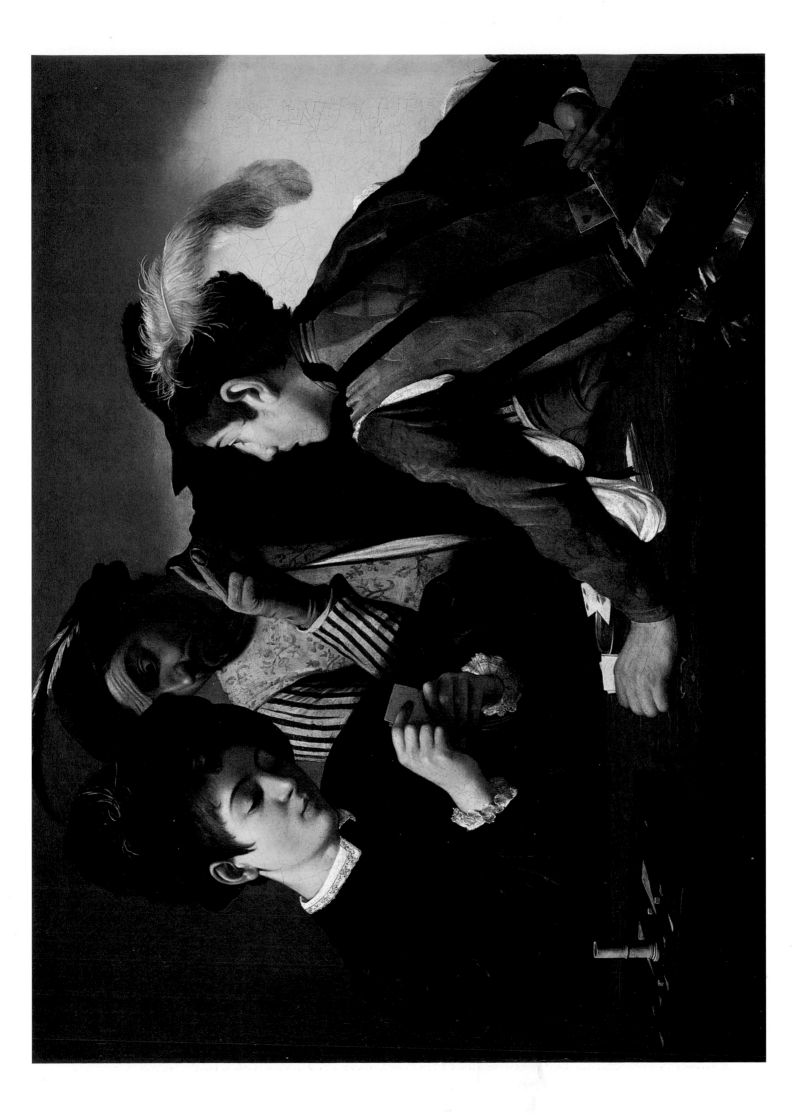

6 The Musicians

c.1595. Oil on canvas, 92 x 118.5 cm. Metropolitan Museum of Art, New York

Because he was forgotten for many years, Caravaggio's paintings have a way of turning up unexpectedly. This picture, probably the first work executed by him for Cardinal Del Monte, is one of the most exciting rediscoveries of the postwar period. Though not in a good condition when found, it has been skilfully restored; and it provides attractive evidence of the aesthetic revolution effected by its creator in his early Roman period.

The subject of a group of musicians was first made common by Giorgione and his followers, but the predecessors to Caravaggio's youths are invariably women. By way of contrast, Caravaggio makes his figures resemble the members of the predominantly male Del Monte household. They are not to be understood as individuals whom Caravaggio was asked to portray but are probably meant to rival the beautiful women musicians in Veronese's *Allegory of Music* (fig. 18) in the Libreria Marciana, Venice, which would have been familiar to the musical Venetian-born cardinal. The boy at back left, with wings and arrows, is Cupid, whose Bacchic grapes suggest the music's sensuous appeal. One musician holds a horn (at back right), the second a lute (at front left) and the third a sheet of music (at front right). Their costumes hint at antiquity, yet are modern – another way in which Caravaggio gives a contemporary feel to the scene. It is impossible to make out the notes or words of the music, but the lutanist's meaning is clear, for while he sings his wistful air, the viewer is invited to take up the violin to accompany him in a duet. The lutanist is appealing for love.

There is another contrast with Veronese. His young women are set out of doors, by classical buildings in a garden. Caravaggio's boys are hothouse creatures breathing an almost airless atmosphere.

Fig. 18
PAOLO VERONESE
Allegory of Music
1556–7. Oil on canvas,
diameter c.130 cm.
Libreria Marciana, Venice

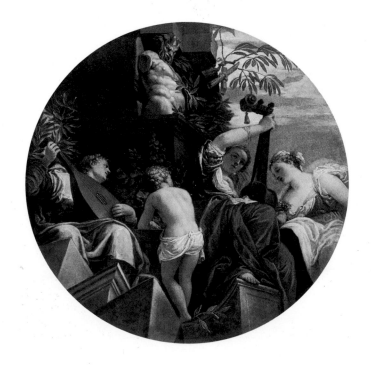

The Lute-Player

*c.*1595–6. Oil on canvas, 94 x 119 cm. The Hermitage, St Petersburg

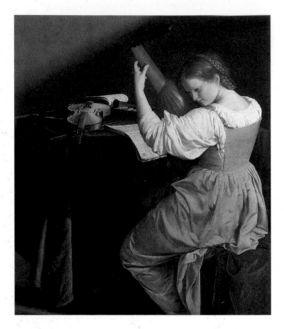

Fig. 19
ORAZIO GENTILESCHI
Female Lute-Player
*c.*1615. Oil on canvas,
144 x 129 cm.
National Gallery of Art,
Washington DC

This painting, mentioned in Del Monte's inventory, shows a single lutanist singing a love song; and a related 'carafe with flowers' is also listed in the catalogue of the Del Monte sale. From the seventeenth century there have been uncertainties about the gender of the singer. Baglione and the Del Monte inventory call him a boy; Bellori, who knew only a copy, calls him a girl. There are reasons for this confusion. One is the Renaissance fascination with androgyny – the singer is not much older than Shakespeare's Rosalind, who renamed herself Ganymede, and Viola, who renamed herself Cesario – and another is the Italian fashion for castrati. The lutanist, with parted lips, sings of love from the madrigal *Voi sapete ch ['io v'amo]* (*you know that [I love you]*) by the Flemish composer Arcadelt. In front of him are a violin and bow which invite the spectator to take part in a duet with him; the fruit and the vegetables, and indeed the music itself, imply the harmony that should exist between lovers.

Among the early works this painting must count as a virtuoso performance. The glass carafe and its flowers are painted with assured mastery, and Caravaggio is also aware of the problems of perspective that lutes and violins could cause; and he spotlights the the solo player and his instruments so as to make them the main focus of attention, the carafe of flowers so that they are a secondary focus. One of his most talented followers, Orazio Gentileschi, was to paint a girl lutanist with a more beguiling sense of poetry (fig. 19), but without the sense of immediacy that was the hallmark of his master's craft.

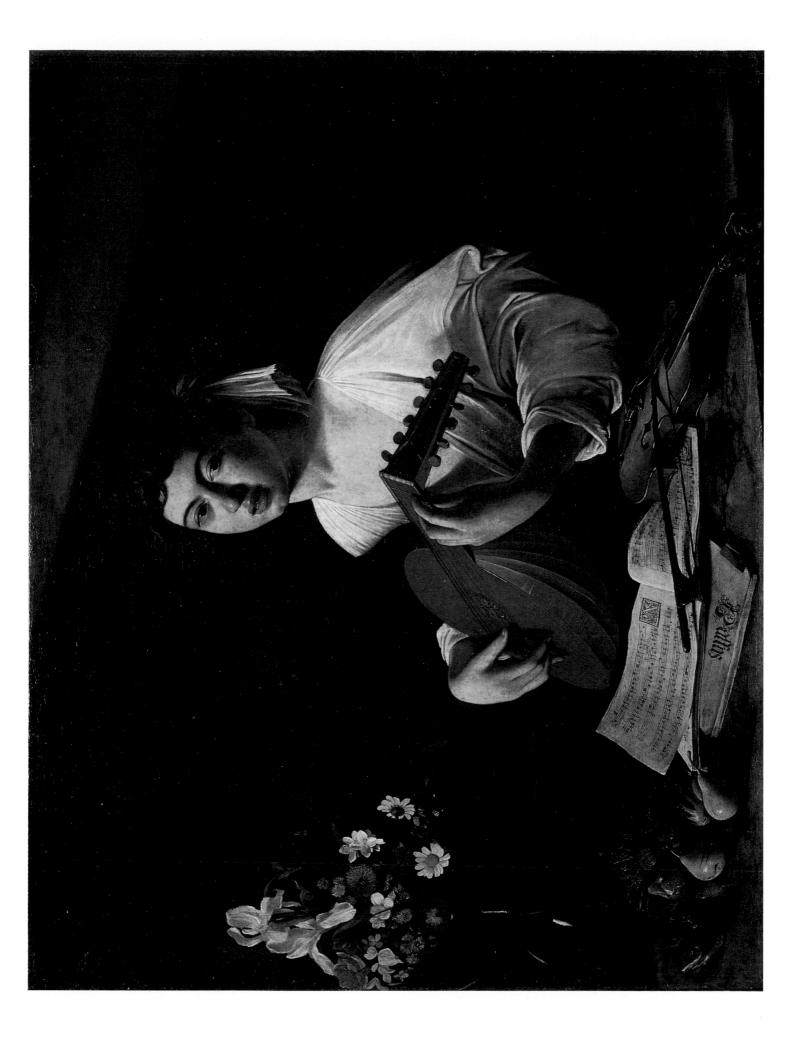

The Rest on the Flight into Egypt

*c.*1595. Oil on canvas, 130 x 160 cm. Galleria Doria Pamphilj, Rome

This most lyrical of Caravaggio's early paintings is also one of the strangest. *The Rest on the Flight into Egypt* shows a young sleeping mother, surely modelled on the same girl whom he used for the *Penitent Magdalen*, holding a sleeping Christ Child while an androgynous angel, violin in hand, plays from a part-book that the elderly Joseph holds for him, and a benign donkey stands at Joseph's shoulder under the branches of the oak-tree that shelters the Holy Family. Some modern critics have been so excited by the 'provocative' nudity of the angel that they have failed to notice the ingenious way in which Caravaggio avoids the question of sex by turning the angel's back to the viewer; others, more naturalistically inclined, have commented on the angel's pigeon wings; and musicians have drawn attention to the angel's score. Research has shown that this comes from a motet, *Quam pulchra es* (*How Beautiful Thou Art*), written in honour of the Virgin Mary by the Franco-Flemish composer Noël Bauldewijn. The main impression the painting gives, with its juxtaposed yet unrelated details, is of a naïve religious vision – Caravaggio was not yet intent on bringing a sense of naturalness to sacred scenes. The mannered swirling draperies and the mellow colours reinforce the picture's dream-like quality. Although other influences have been argued, one artist seems closest to Caravaggio in this mood: Lorenzo Lotto. Among his completed paintings are a Holy Family reclining in a similarly leafy setting (fig. 20) and one Madonna, who witnesses *The Mystical Marriage of St Catherine* (fig. 21), bending her head in the expressive way that Caravaggio was to make peculiarly his own. Caravaggio might well have acquired this sensitivity from Lotto.

Fig. 20
LORENZO LOTTO
Madonna and Child
with Saints Catherine
and James
*c.*1528–30. Oil on canvas,
113.5 x 152 cm.
Kunsthistorisches
Museum, Vienna

Fig. 21
LORENZO LOTTO
The Mystical
Marriage of St
Catherine with
Niccolò Bonghi
1523. Oil on canvas,
172 x 134 cm.
Accademia Carrara,
Bergamo

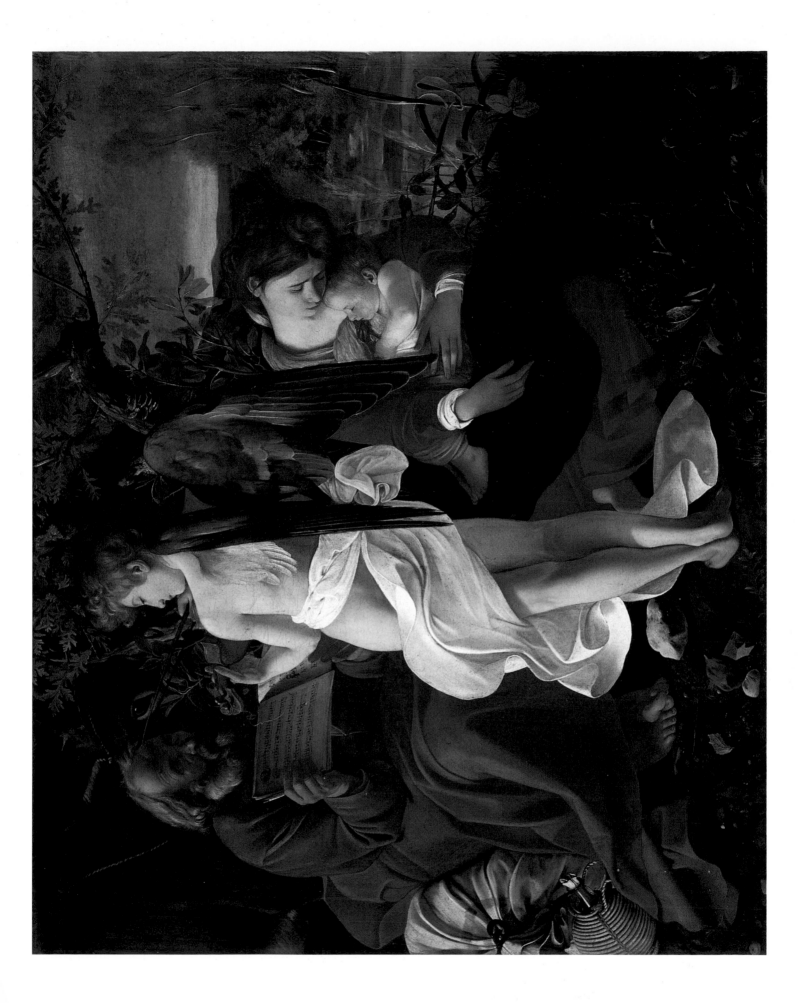

St Francis in Ecstasy

*c.*1596. Oil on canvas, 92.5 x 128.4 cm. Wadsworth Atheneum, Hartford

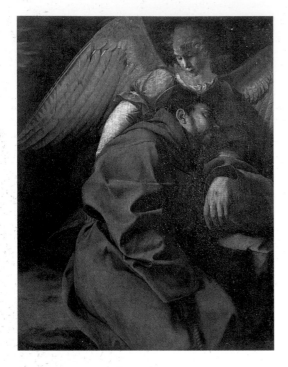

Fig. 22
ORAZIO GENTILESCHI
St Francis in Ecstasy
*c.*1605. Oil on canvas,
126 x 98 cm.
Museo del Prado, Madrid

St Francis of Assisi, though he had died in 1226, became one of the heroes of the Counter-Reformation. The Franciscan order, following the foundation of the Capuchins in 1529 (the last in a series of movements towards a pristine simplicity of rule), now had a new set of preachers whose style was popular, austere and dynamic. To fit modern devotional needs a new iconography developed, and Caravaggio was one artist who helped to establish it. This early painting, which was soon copied, emphasizes the inwardness of the saint's supreme spiritual experience: the moment when he received the five wounds of Christ in his own body. The saint, depicted as a young adult, reclines in sleep on a leafy slope, while in the background are the dim figures of his followers, one of them the faithful companion of his last days, Brother Leo. Francis's head is gently supported by a young angel, whose right hand holds the saint's girdle. The saint's right hand is held over the tear in his habit that reveals one mark of the stigmata, the wound in his chest, and his left hand is opened up in an unconscious gesture of self-surrender. Caravaggio's use of chiaroscuro has the effect of making it hard to read parts of the picture – what the angel's left hand is doing, the structure of the saint's lower body – but also of focusing attention on the mood of tender solicitude, shown by the angel, and of ecstatic self-abandonment, shown by the saint.

Among his followers Orazio Gentileschi painted a characteristically graceful *St Francis in Ecstasy* (fig. 22).

Bacchus

*c.*1597. Oil on canvas, 95 x 98 cm. Galleria degli Uffizi, Florence

Fig. 23
ANNIBALE CARRACCI
The Bean-Eater
*c.*1583–4. Oil on canvas,
57 x 68 cm.
Galleria Colonna, Rome

This painting, which lay for years in the storerooms of the Uffizi till its identification in 1917, is the most mature of the early Bacchus pictures. Its history is unknown, but its importance is clear. Some ten years before Caravaggio arrived in Rome, Annibale Carracci had given a snapshot effect to his portrayal of a man eating beans (fig. 23). The younger man's use of the device here is more subversive.

The young god, lolling on an antique bed, offers a glass of wine to his potential drinking companion, the viewer. His finger nails are dirty, the fruit before him rotten, and his figure has gone to seed – he has the body, seldom exposed to the light, of a person who prefers self-indulgence to self-exertion. Of all Caravaggio's semi-classical boys and young men, the Uffizi Bacchus is the most knowingly seductive. His full lips, his rounded cheeks, his plucked eyebrows, his head-dress of vine-leaves and grapes, his slanting glance – all suggest an invitation to a life of languor and decadence. His heavy chest may well derive from one of the statues of Antinous, favourite of the Emperor Hadrian, that had inspired Italian artists from the time of Donatello. As always, Caravaggio wears his visual learning lightly. It is not just his ability to bring mythology into the modern age that is so striking – he shows the fleshy hands of Bacchus to be sunburnt – but also the attention he gives to the shadow cast by the wine carafe, to the god's hand and costume seen through the stem of his glass, and to the penumbra of darkness that surrounds him. The theme is a disturbing one, but there is monumental grandeur in its development.

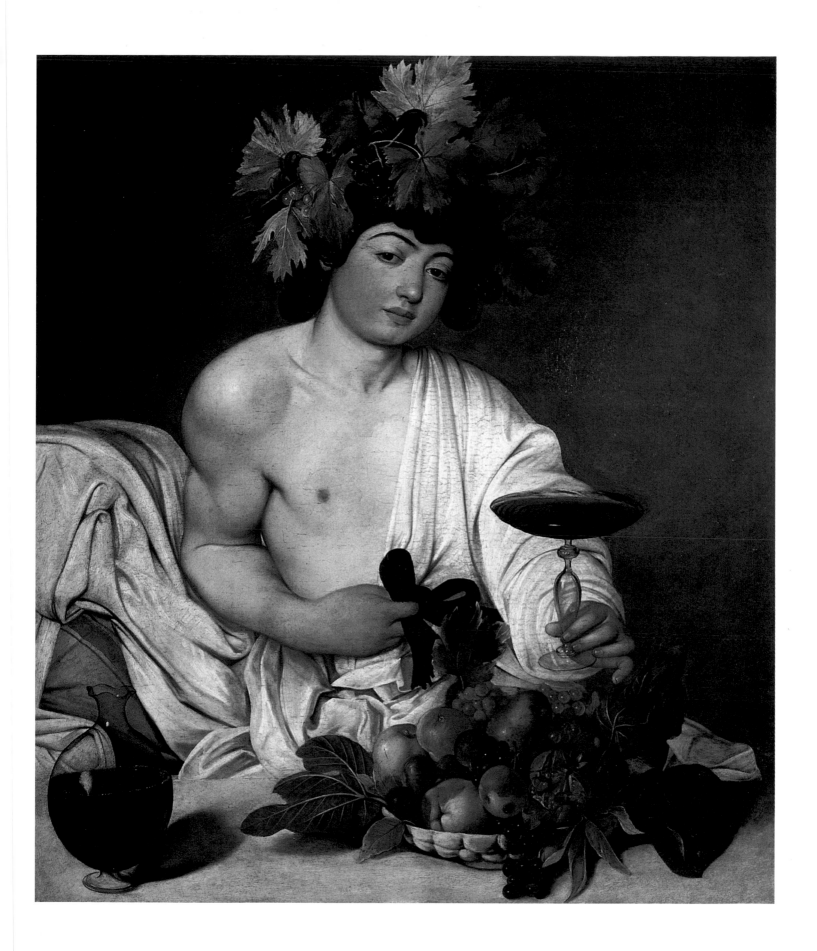

c.1598–9. Oil on canvas, 99 x 131cm. Musée du Louvre, Paris

According to Bellori, Caravaggio took a gypsy from the street and portrayed her in the act of fortune-telling, and then he painted a young man who holds a sword in one hand and offers the other to her for inspection. The painting tells a more subtle tale. The adolescent looks longingly into her eyes as she points to the girdle of Venus on his palm while gently removing the gold ring from his finger. Her deception and his folly are only hinted at. In the earlier painting of the *Cardsharps* there is an all-pervasive sense of evil; and in the *Gypsy Fortune-Teller* by the Caravaggesque Manfredi (fig. 24) the drama has expanded to include four figures and the thefts have multiplied accordingly.

Giorgione's *The Tempest* was first catalogued as a painting of a soldier and a gypsy, and the same description could also be given to this painting by Caravaggio, to whom Federico Zuccaro attributed Giorgionesque tendencies; but the moral values and atmosphere of Caravaggio's painting are far removed from the remote and haunting world of *The Tempest*.

This picture was sold on the open market and was seen around 1620 in the collection of Alessandro Vittrice by Mancini, who described it as beautifully painted. Later it was owned by the family of Pope Innocent X and then given to Louis XIV. It was damaged on its way to France and the upper part of the picture, including the feather in the boy's cap, must be the work of a restorer, but the charm of the scene has survived intact. (For an earlier version of the same subject, see fig. 6, p. 10.)

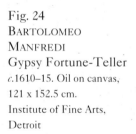

Fig. 24
Bartolomeo
Manfredi
Gypsy Fortune-Teller
c.1610–15. Oil on canvas,
121 x 152.5 cm.
Institute of Fine Arts,
Detroit

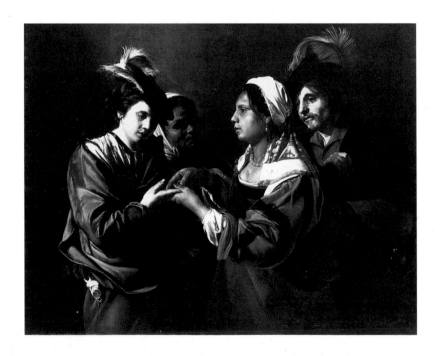

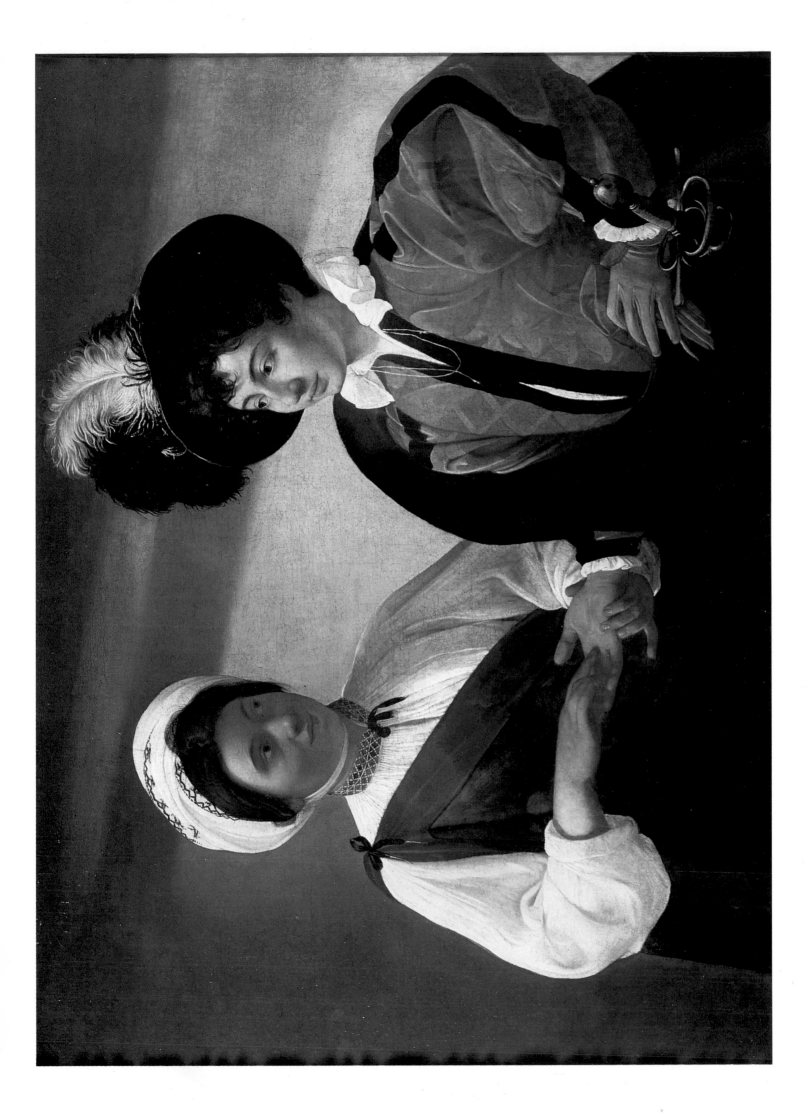

13 The Conversion of Mary Magdalen

*c.*1598–9. Oil on canvas, 97.8 x 132.7 cm. Institute of Fine Arts, Detroit

The conversion of Mary Magdalen from a life of sensuality to one of devotion, even if the idea was based on a misreading of the texts of the New Testament, became a favourite subject of Counter-Reformation artists. The present painting, perhaps a copy of an original, gives a curiously rational view of a moment of choice. Choice, however, was emphasized by Catholic piety, since it implied the rejection of Protestant notions of predestination. Gaudily dressed in her finery, Mary holds in her left hand a mirror, signifying either vanity or reality or both, while she turns her head to listen to the pleadings of her sister Martha, half hidden in shadow. For once Martha not Mary has the more refined face, but it seems that the model for Mary mattered more to Caravaggio, for she reappears in two other works of this period: *St Catherine of Alexandria* and *Judith Beheading Holofernes* (Plates 14 and 15).

St Catherine of Alexandria

c.1599. Oil on canvas, 173 x 133 cm. Fundación Colección Thyssen-Bornemisza, Madrid

The model who had been Mary Magdalen at the moment of her conversion is used again, this time as one of the most popular female martyrs of the early Church. The saint chose to be broken on wheels with sharp protruding razors (whence 'Catherine wheels') and to be beheaded rather than renounce her virginity or her faith. In much the largest painting that he produced for Del Monte, Caravaggio shows the saint as a contemplative, herself the object of contemplation. She rests against a huge wooden wheel, with her neck exposed to the light, and holds in her hands an elegant bloody rapier while kneeling in a sumptuous robe – she was of royal blood – on a bright red cushion, on which palms of martyrdom are strewn. Her manner seems almost casual, even detached, so that the sadistic instruments of her torture and death are only so many stage props.

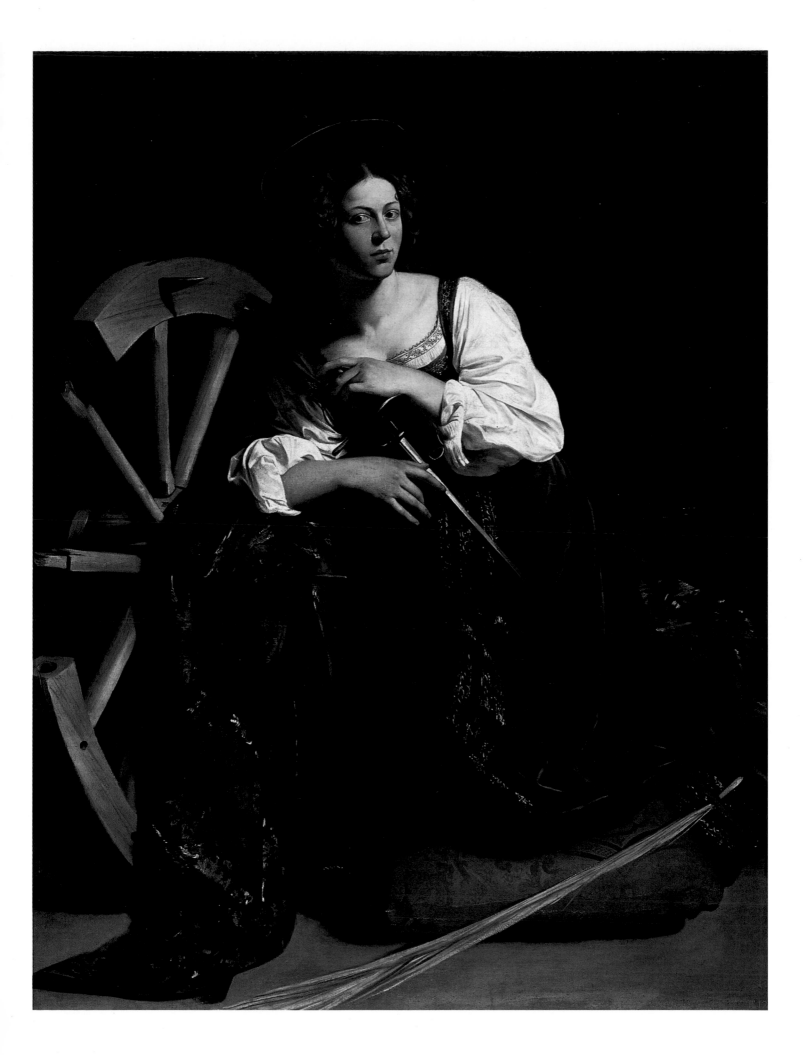

Judith Beheading Holofernes

*c.*1599. Oil on canvas, 144 x 195 cm. Palazzo Barberini, Rome

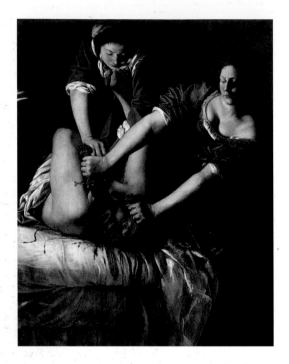

Fig. 25
ARTEMISIA
GENTILESCHI
Judith Beheading
Holofernes
*c.*1612–13. Oil on canvas,
159 x 125.5 cm.
Museo di Capodimonte,
Naples

According to Baglione, this work was painted for Ottavio Costa, who referred to it in his will of 1632. In Caravaggio's career it marked a new departure, for it was the first of his paintings to centre on a brutal action. Previous artists, like Donatello sculpting a piece to balance his bronze *David* in the courtyard of the Medici palace in Florence, had made Judith fierce, without forgetting that her beheading of Holofernes was as much a metaphor of Christ's fight against evil as David's beheading of Goliath (and both scenes can be found opposite each other at the east end of the Sistine Chapel ceiling). In the case of Caravaggio, however, the horror of the action becomes the painting's primary concern. At right angles to the bed on which the Syrian general writhes and screams in agony, Judith stands erect and determined as she slices through his neck, while from the side, in profile, her crone of a servant urges her on. The colour of the blood pouring from Holofernes's neck is taken up in the duller red of the curtain above him. His white sheets and Judith's white shirt gleam in the light with merciless purity. The composition is so enclosed that neither the eye of the viewer nor the actors themselves can escape its brutal focus.

The behaviour of Caravaggio's Judith has turned her into a feminist icon, in so far as Artemisia Gentileschi, the daughter of his follower Orazio, took to the subject with zeal after her alleged rape by her father's assistant Tassi (fig. 25). Artemisia may have had good reason for sympathizing with Judith, and fine Caravaggesque painter though she was, she could not compare with the master in terms of cold, concentrated sadism.

The Martyrdom of St Matthew

1599–1600. Oil on canvas, 323 x 343 cm. San Luigi dei Francesi, Rome

Nothing that Caravaggio had done before was equal in scale, majesty or beauty to the first painting he produced for the Contarelli Chapel in San Luigi dei Francesi, the French Church in Rome. The *Martyrdom of St Matthew* hangs on the right wall of the Contarelli Chapel and is lit from the left, as if from the window behind the altar. It dramatizes the end of the saint's life as a follower of Christ, and relies upon *The Golden Legend*, a collection of stories of the saints, according to which Matthew was killed in Ethiopia for forbidding the marriage of the king to a virgin-princess, whose earlier miraculous resuscitation by the saint had been painted by the Cavaliere d'Arpino on the chapel ceiling. *The Golden Legend* tells how Matthew was seized and murdered after Mass; and so the scene is set in a church, with a dimly discernible altar where a single candle burns at the back, from which steps descend to a baptismal pool in the foreground. Scantily clad men to left and right (the two to the right locked together almost like Siamese twins) await immersion. The twisted, muscular, near-naked executioner stoops over them to dispatch the reclining saint with one stroke of his sword, while terrified worshippers, in contemporary dress, recoil in fear and one boy screams. All seems to be turmoil and confusion, however carefully controlled. The composition would be centrifugal were it not for the rigid geometry that holds it in place. If its ultimate meaning is shown by the angel who reaches down to proffer the palm of martyrdom, then it is given human significance by the worried face of Caravaggio himself, who turns round at the back of the group to watch what is about to occur.

Counter-Reformation piety rejoiced in the grizzly deaths of the faithful, and there were many recent paintings on which Caravaggio could draw. A decade earlier, Muziano had painted the same scene for the Jesuits in the church of Santa Maria in Aracoeli, but Caravaggio was influenced more by the fluent movement evident in finer works of art, such as Titian's *Death of St Peter Martyr* in Venice, which was destroyed in the nineteenth century. X-ray photography has shown that originally *The Martyrdom of St Matthew* was closer to Muziano's version. In turning to Titian, Caravaggio was learning to compete with the great.

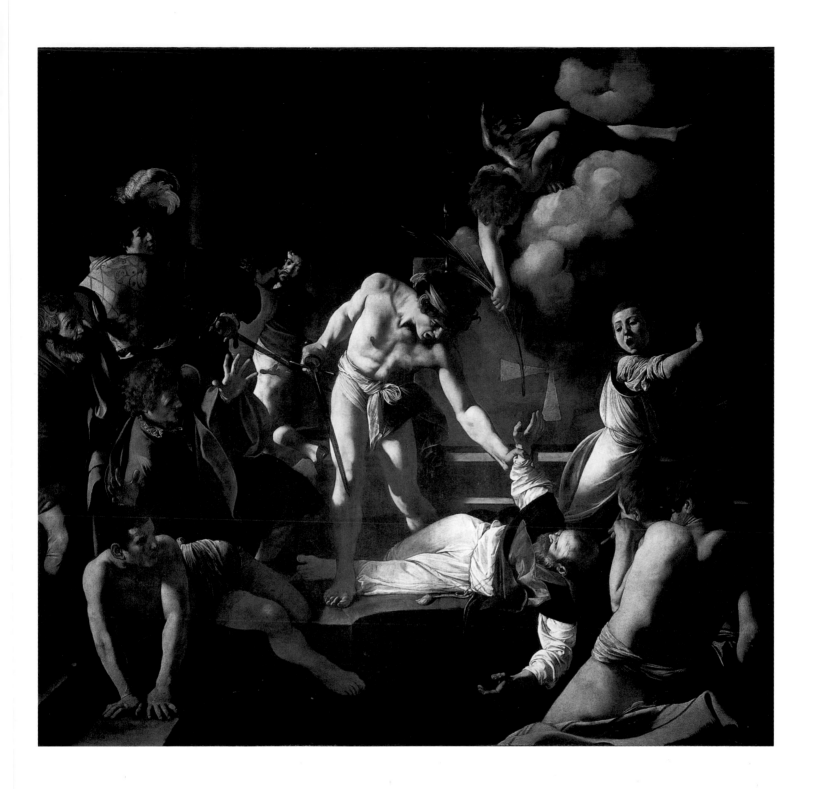

The Conversion of St Paul

1600–1. Oil on canvas, 230 x 175 cm. Santa Maria del Popolo, Rome

In 1600, soon after he had completed the first two canvases for the Contarelli Chapel, Caravaggio signed a contract to paint two pictures for the Cerasi Chapel in Santa Maria del Popolo. The church has a special interest because of the works it contains by four of the finest artists ever to work in Rome: Raphael, Carracci, Caravaggio and Bernini. It is probable that by the time Caravaggio began to paint for one of its chapels, *The Assumption* by Annibale Carracci (fig. 3, p. 7) was in place above the altar. Caravaggio's depictions of key events in the lives of the founders of the Roman See have little in common with the brilliant colours and stylized attitudes of Annibale, and Caravaggio seems by far the more modern artist.

Of the two pictures in the chapel the more remarkable is the representation of the moment of St Paul's conversion. According to the Acts of the Apostles, on the way to Damascus Saul the Pharisee (soon to be Paul the Apostle) fell to the ground when he heard the voice of Christ saying to him, 'Saul, Saul, why do you persecute me?' and temporarily lost his sight. It was reasonable to assume that Saul had fallen from a horse.

Caravaggio is close to the Bible. The horse is there and, to hold him, a groom, but the drama is internalized within the mind of Saul. He lies on the ground stunned, his eyes closed as if dazzled by the brightness of God's light that streams down the white part of the skewbald horse, but that the light is heavenly is clear only to the believer, for Saul has no halo. In the spirit of Luke, who was at the time considered the author of Acts, Caravaggio makes religious experience look natural.

Technically the picture has defects. The horse, based on Dürer, looks hemmed in, there is too much happening at the composition's base, too many feet cramped together, let alone Saul's splayed hands and discarded sword. Bellori's view that the scene is 'entirely without action' misses the point. Like a composer who values silence, Caravaggio respects stillness.

Both this and the following painting appear to be second versions, for Baglione states that Caravaggio first executed the two pictures 'in another manner, but as they did not please the patron, Cardinal Sannesio took them for himself'. Of these earlier versions, only *The Conversion of St Paul* survives (see fig. 9, and p. 23 of the Introduction for mention of other rejected works).

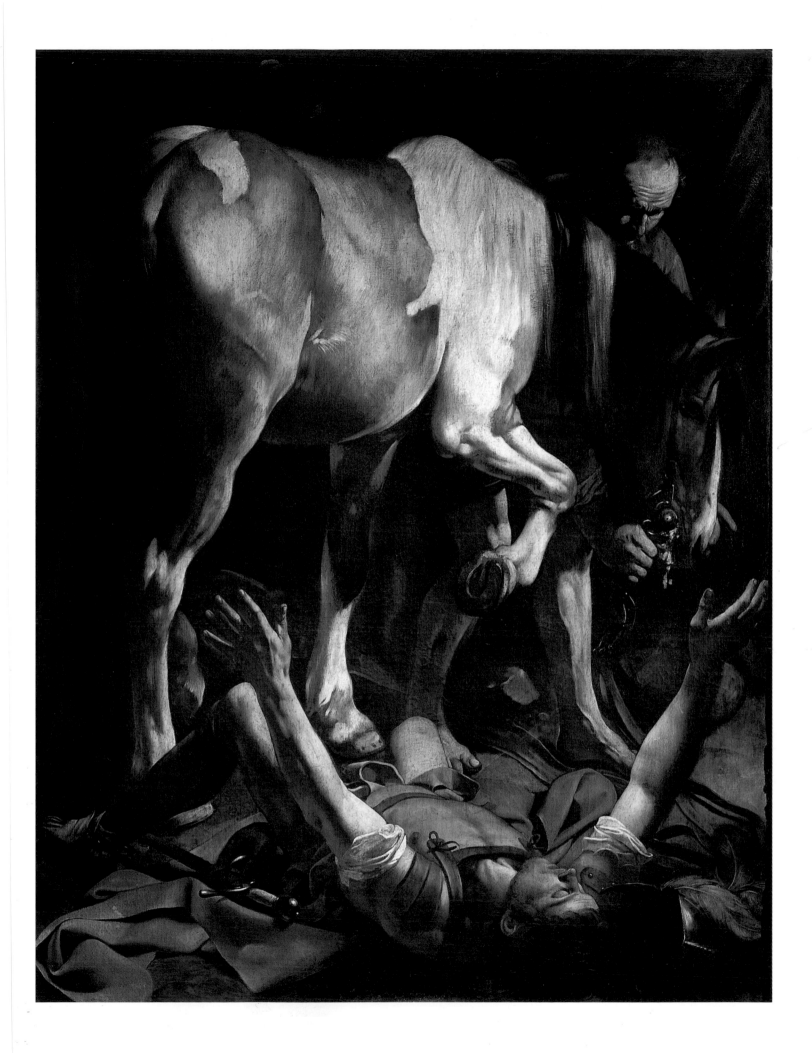

Supper at Emmaus

1601. Oil on canvas, 139 x 195 cm. National Gallery, London

Fig. 28
MICHELANGELO
Last Judgement
(detail of Christ)
1536–41. Fresco.
Sistine Chapel, Vatican,
Rome

Fig. 29
TITIAN
Supper at Emmaus
c.1600. Oil on wood,
169 x 244 cm.
Musée du Louvre, Paris

The dating of this picture used to be problematical. If its concentration on fruits and flowers might indicate a date prior to the grand religious commissions, its dramatization of a sacred moment would place it in the early seventeenth century. In fact it was commissioned by Ciriaco Mattei and paid for in 1601, then in 1605 it was bought by Cardinal Scipione Borghese, and remained in the family collection till Prince Camillo Borghese married a Bonaparte.

The sacred moment occurs when two disciples, who had walked with a stranger to the village of Emmaus, recognized him as Jesus 'in the breaking of bread'. The one to the left, who pushes his patched elbow out of the picture space, must be the disciple named by Luke as Cleophas, for the one to the right is usually considered to be St Peter or, because of his pilgrim's badge, St James (the Santiago who is venerated at Compostella). Both react with violent clumsy gestures, while the host, oblivious of any spiritual happening, stays calm.

Many of the still-life details, though realistic in appearance, are there for symbolic reasons – the autumnal grapes, apples and pomegranate refer respectively to the wine of the Eucharist (in the carafe), the Fall of Man and the Crown of Thorns. The bread of the Eucharist, which in Caravaggio's time was the sole means of communion for the laity, is placed under Christ's left hand and near the front of the table, as on an altar.

In painting this picture Caravaggio showed many debts, ultimately to Leonardo's *Last Supper* and to Christ's blessing and cursing hands in *The Last Judgement* of Michelangelo (fig. 28), but he may have been thinking also of a *Supper at Emmaus* by Titian (fig. 29). What makes this work notable is first the way he uses light both naturalistically and, as on Christ's face, for its spiritual significance; and secondly, for his portrayal of the Saviour's face as clean-shaven, fleshy, even ugly.

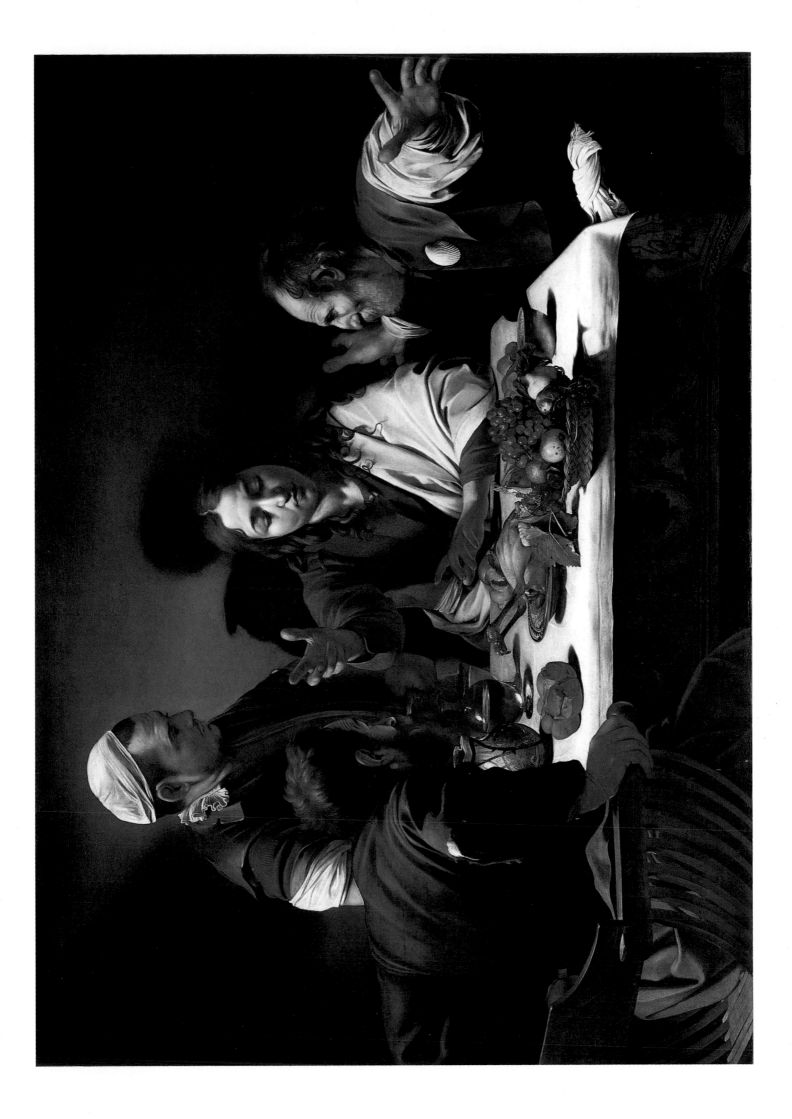

Still Life with a Basket of Fruit

*c.*1601. Oil on canvas, 31 x 47 cm. Pinacoteca Ambrosiana, Milan

Among the works in Del Monte's collection was a still life that measured 2 *palmi* or hands. As this picture measures 1½ x 2 *palmi*, it could be a variant, yet is known to have been in the collection of Cardinal Federico Borromeo, who founded the Ambrosiana, as early as 1607, and might have been a present from Del Monte. It is the ideal type of painting to be in Milan, since it is one of the finest examples of its kind to demonstrate a skill for which Lombard artists were prized. There is no sign of the occasional awkwardness that marks some of the painter's figures, and yet the *Still Life with a Basket of Fruit* has a characteristic touch in the way that it projects into the spectator's space, a device made possible by the low viewpoint from which it is seen. If this work was valued by a member of one of the most distinguished families of the princes of the Church, that may have been because Caravaggio gives great dignity to simple objects – grapes, apples and leaves – asymmetrically arranged.

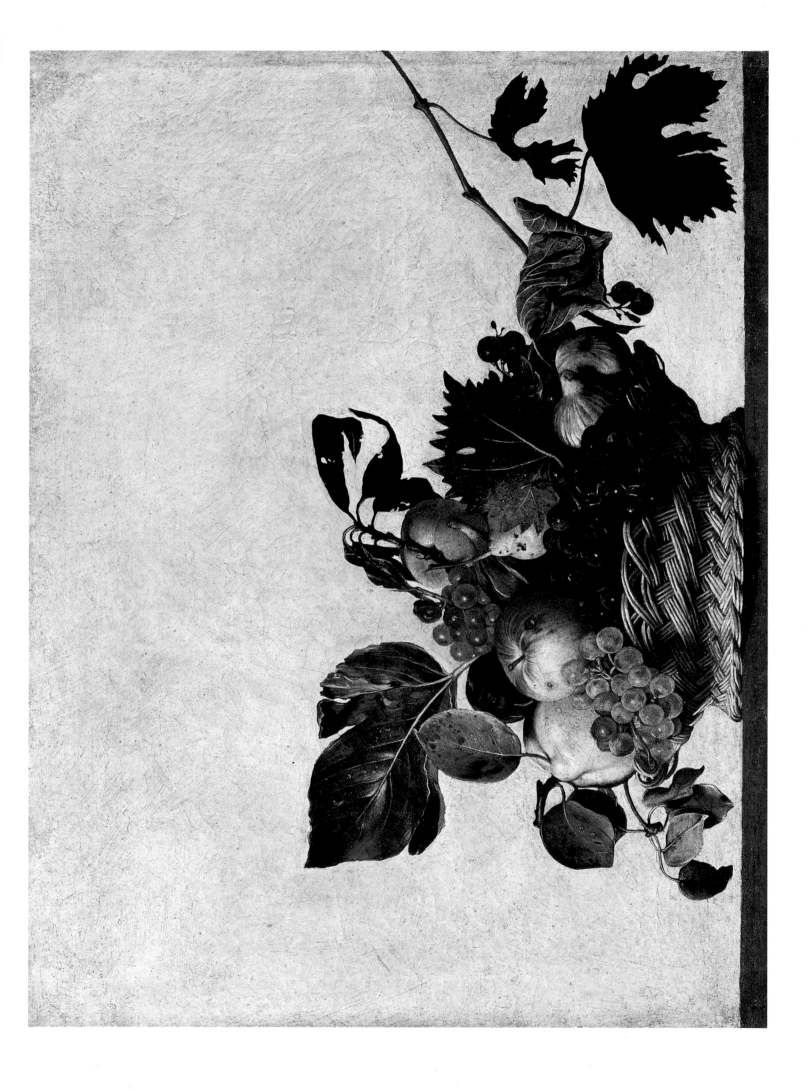

Cupid

c.1601. Oil on canvas, 154 x 110 cm. Staatliche Museen, Berlin

Fig. 30
MICHELANGELO
Victory
1525–30. Marble,
height 261 cm.
Palazzo Vecchio, Florence

As Caravaggio was a disturbing man, we should not be surprised if we find his art disturbing. Around the same period in his life as he painted his first ambitious religious pictures, he also produced his final and most impudent secular work. This painting has been given the alternative title of *Amor Vincit Omnia*, implying that the love which conquers all is the love of Eros; and yet the painting was commissioned by Giustiniani, who was a devout man, and its intentions may be misunderstood today.

Cupid (or Eros) has a torso that recalls Michelangelo's *Victory* (fig. 30); but he has a cheeky charm that is all his own. At first glance he is stepping out of bed but closer examination reveals that he is treading over the symbols of learning. Near his right leg lie a score, an old lute and a new violin (music), a T-square and compass (geometry), and a stellar globe (astronomy). He ignores the lives of a soldier (armour), a scholar (book and quill), a ruler (crown and sceptre, at back right) and even fame itself (the laurel wreath).

It has become a commonplace of modern criticism to see Caravaggio as a member of some homosexual set. In 1603 Baglione, who brought an action of libel against him, accused him of having a catamite ('bardassa') called Giovanni Battista. This may mean only that this boy was his model, and Caravaggio was revolutionary in the care with which his models were depicted. Giustiniani had invited him to represent the power of erotic love, a commission he effected with startling success.

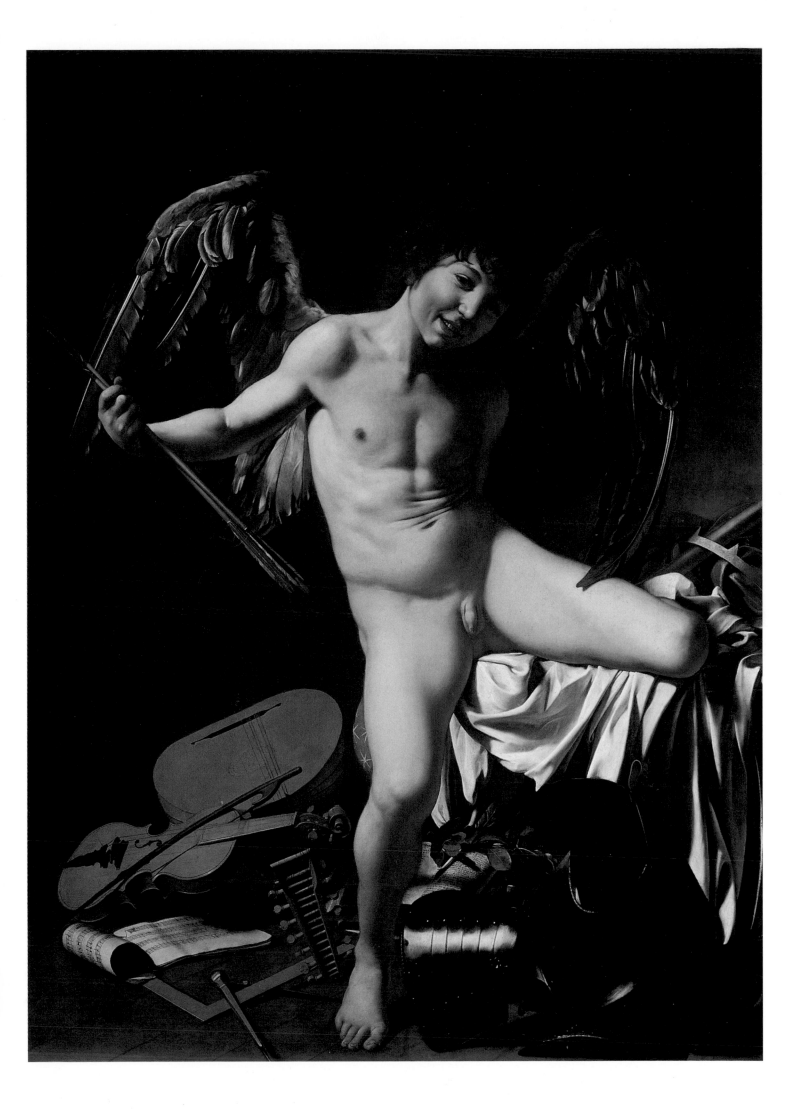

Death of the Virgin

*c.*1601–3. Oil on canvas, 369 x 245 cm. Musée du Louvre, Paris

This, the largest picture that Caravaggio had yet produced, did not end up in the place for which it was made. In 1602 a papal legal adviser, Laerzio Cherubini, commissioned a *Death of the Virgin* for the Carmelite church of Santa Maria della Scala in Trastevere; it was to be finished by 1603. When they saw it, the friars found it alarming, because the Madonna was modelled on a prostitute with whom Caravaggio was in love (according to Mancini), because her legs were exposed (Baglione), because her swollen body was too realistic (Bellori) – for whichever reason, they felt prompted to reject it. After Caravaggio had left Rome, Rubens urged his master, the Duke of Mantua, to buy it. Along with the rest of the movable Gonzaga collection it was bought by Charles I of England and, after he had been executed, was sold to Louis XIV. What the friars could not endure was favoured at court.

The painting is severe, sad and still. Under a red canopy hanging from a barely visible ceiling, the disciples are grouped round the corpse (fixed on a bed in *rigor mortis*), most standing to the left. Light coming from a window high on the left picks out their foreheads and bald pates, before falling on the upper part of the Virgin's body. Above her stands the young, mourning St John the Evangelist who had been given special charge of her; in front, the seated Mary Magdalen stoops forward and almost buries her head in her lap.

In the predominant colours – red, orange, dark green – Caravaggio uses a slightly wider range than in his later, darker Roman paintings, but nowhere else did he achieve a mood of such overwhelming solemnity. Mary's companions, her Son's followers, are struck dumb by their grief, like relief sculptures on antique tombs. There is no suggestion that their sorrow will be turned into joy or that Mary will be assumed into heaven.

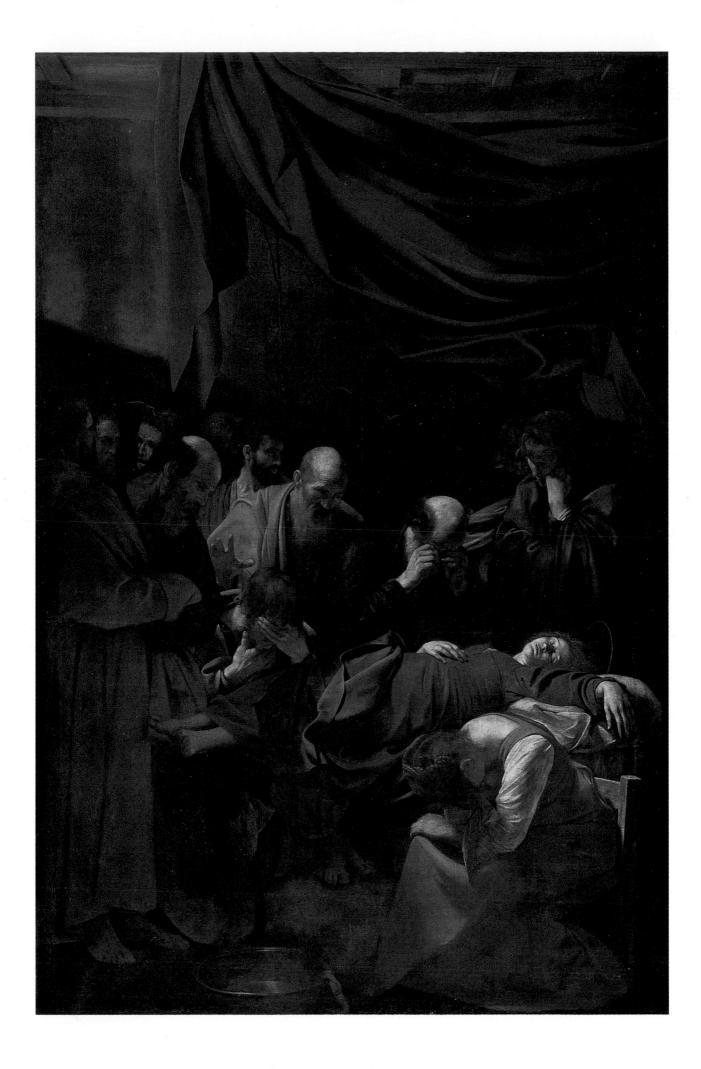

St Matthew and the Angel

1602. Oil on canvas, 296.5 x 189 cm. San Luigi dei Francesi, Rome

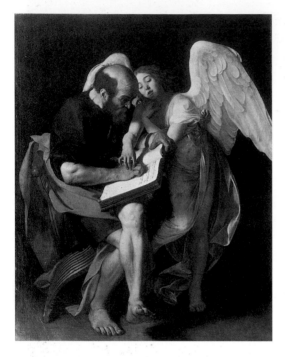

Fig. 31
St Matthew and the
Angel (destroyed)
*c.*1602. Oil on canvas,
232 x 183 cm.
Formerly Kaiser Friedrich
Museum, Berlin

Cardinal Contarelli had always planned that above the altar there should be a painting of St Matthew as Evangelist; and though he had died, his nephew was the rector of the church of San Luigi and well aware of his uncle's intentions. If the painter was in line with traditional Christian iconography, the saint would be writing his gospel with the help of an angel.

The two side paintings were finished in 1600, but this third picture was not ordered till 1602, after Caravaggio had worked in the Cerasi chapel in Santa Maria del Popolo. He produced a strange image, which shows an old man, with careworn brow, writing the account of the genealogy of Christ in Hebrew – Matthew had written for Jewish Christians – while an elegant angel guides his hand across the page of his book. The side-by-side composition may have come from Peterzano. This picture was rejected, then bought by Marchese Vincenzo Giustiniani, already owner of Caravaggio's *Portrait of Fillide*, and so it passed to the Prussian royal collection and was destroyed in 1945 (fig. 31).

Caravaggio's second attempt still had some of the same features that may have led people to think its predecessor indecorous: the saint's feet are soiled, his chair protrudes unsteadily into the spectator's space and his forehead is wrinkled. There is, however, more authority in his pose, even though this time the angel, poised at a safer distance in mid-air, dictates to him the words he must write. The angel is swathed in white robes that curl round his head in graceful arabesques. The saint, in gold and red, is less clumsy than before, quietly attentive to heaven's messenger. His role is to remind the pious Catholic that he knows Christ, Word of God, through the words of the Bible.

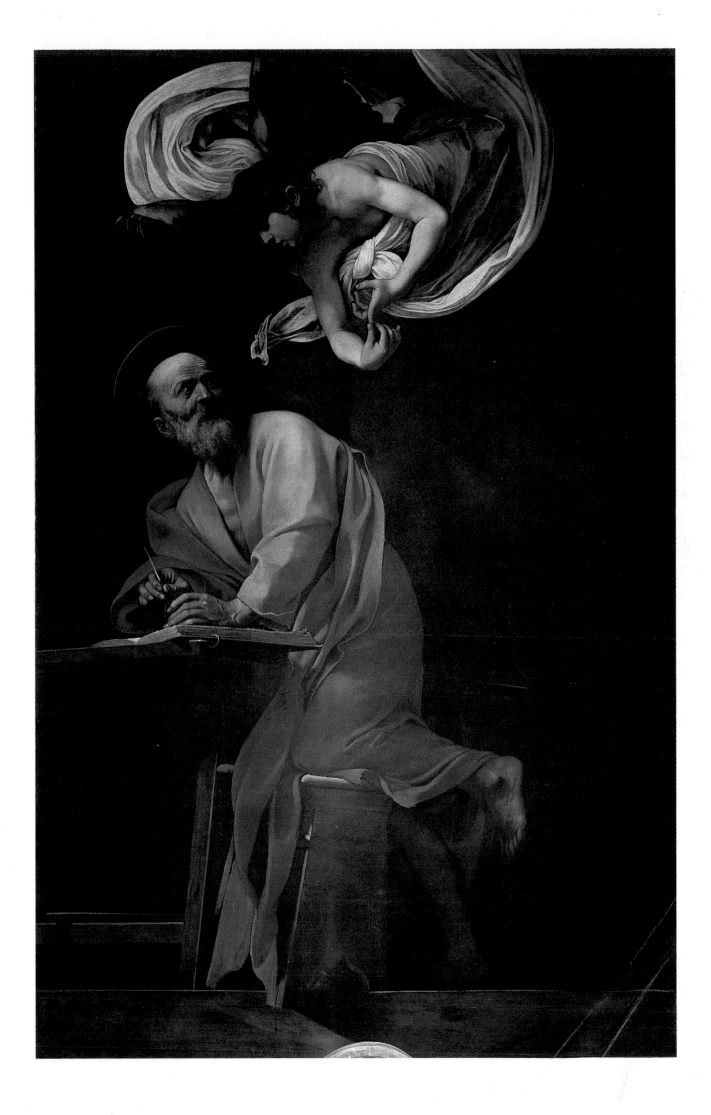

St John the Baptist

1602. Oil on canvas, 129 x 94 cm. Galleria Capitolina, Rome

This picture, painted for Cardinal Mattei's brother Ciriaco, has bewildered critics, for the subject-matter is not clear. Basing himself on an early description of the boy (by the artist Gaspare Celio in 1620) as a 'Pastor friso', a recent commentator argues that this would be the way in which a Lombard would pronounce 'Pastor frigio', Phrygian shepherd, and that the boy is meant to be the adolescent Paris, the prince who for a time lived as a shepherd before he grew up to sacrifice everything – his family, the house of Priam, and his city, Troy – for Helen.

And yet, in the Mattei inventory, the picture seems to be referred to as a *John the Baptist*, the patron saint of Ciriaco's son Giovanni Battista. The Baptist identified Jesus as the lamb of God. Here instead is a ram, probably implying the beast offered to God by Abraham in place of Isaac, an event that foreshadows the self-sacrifice of Christ to God the Father. The powerful *contrapposto* of the pose looks back to one of Michelangelo's slightly older male nudes in the Sistine Chapel, but he is transformed by the youthful Baptist's smile.

The Betrayal of Christ

1602–3. Oil on canvas, 133.5 x 169.5 cm. National Gallery of Ireland, Dublin

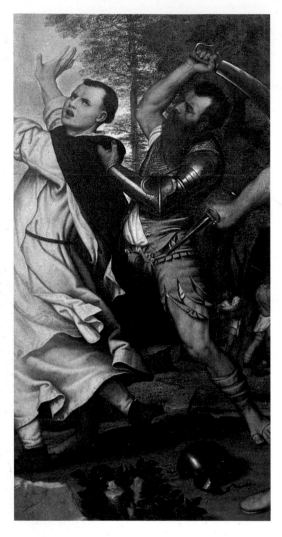

Fig. 32
MORETTO
Death of St Peter
Martyr (detail)
*c.*1530–5. Oil on canvas,
310 x 163 cm.
Pinacoteca Ambrosiana,
Milan

Ciriaco Mattei paid Caravaggio for three pictures: the *St John the Baptist* (Plate 25), a 'painting of Our Lord breaking bread' and one of 'Christ taken in the garden'. This last work, for which the artist received 125 scudi on 3 January 1603, was rediscovered in a Jesuit convent in Dublin in 1990. Before then, it had been known only through copies.

Working for a family whose head, Cardinal Girolamo, was a fervent supporter of the Observant Franciscans, Caravaggio painted one of his most moving religious works. In the far right the painter, holding a lantern, peers over the shoulders of members of the Temple guard to watch how Christ will react. His eyes direct the spectator leftwards past the soldier's gleaming bracelet and across an arc of three heads towards the light shining in the darkness that envelops Christ. He sees the anxious Judas both clutching at Christ and pushing Him away; the betrayer's face (in profile) and the face of the betrayed (seen frontally) are enclosed in the same area of light, with a swirling drapery above them and a mailed arm beneath them; beyond, a terrified disciple cries out as he tries to flee the picture. In choosing this gesture, Caravaggio was guided by a memory of a stray figure from a painting by Moretto in Milan (fig. 32) and by the observation of an antique dancer from a Roman sarcophagus, while for the fully clad soldier to the front he relied on his knowledge of Lombard armour of the late sixteenth century. From such disparate elements he fashions one of his most striking images, that has the rare advantage of being unfamiliar.

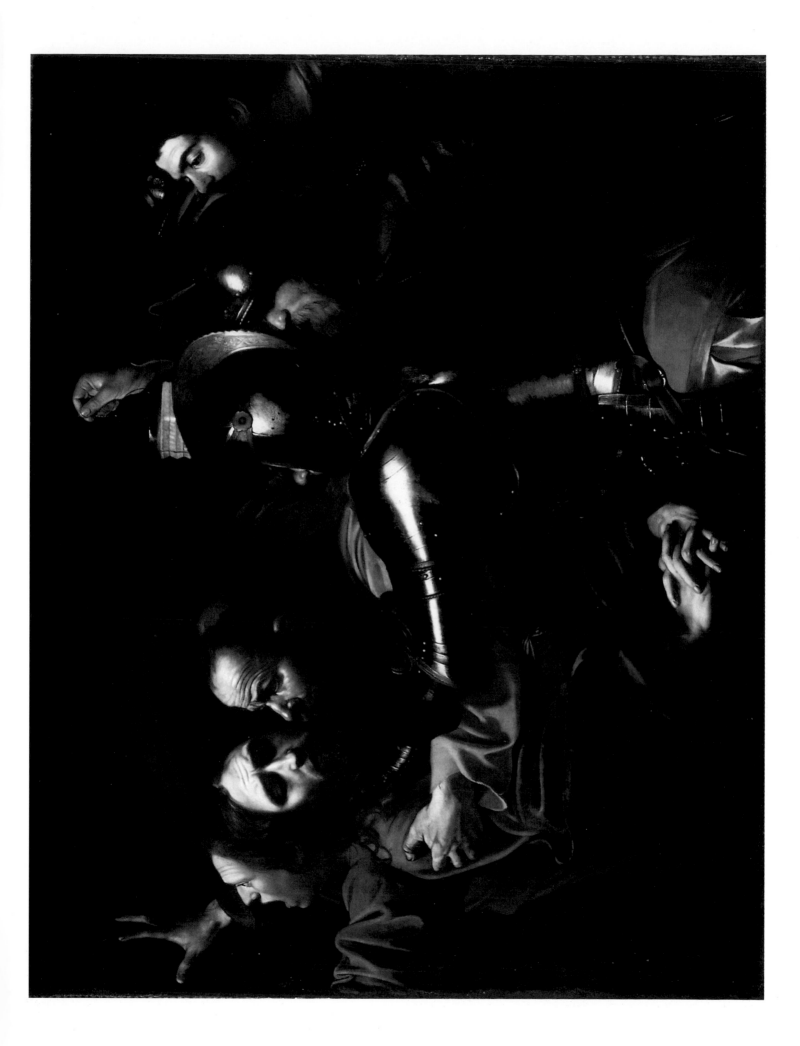

Doubting Thomas

1602–3. Oil on canvas, 107 x 146 cm. Sanssouci, Potsdam

This picture seems to belong to the same group as the second *St Matthew and the Angel* (Plate 24) and *The Sacrifice of Isaac* (Plate 29) because the same model reappears as the apostle at the apex of this composition. Like the first *St Matthew and the Angel* this picture belonged to Vincenzo Giustiniani and then entered the Prussian royal collection. Fortunately it was kept in Potsdam and so it survived the last war intact.

According to St John's Gospel, Thomas missed one of Christ's appearances to the Apostles after His resurrection. He therefore announced that, unless he could thrust his hand into Christ's side, he would not believe what he had been told. A week later Christ appeared, asked Thomas to reach out his hands to touch Him and said, 'Blessed are those who have not seen and yet have believed.'

This drama of disbelief seems to have touched Caravaggio personally. Few of his paintings are physically so shocking – his Thomas pushes curiosity to its limits before he will say, 'My Lord and my God.' The classical composition carefully unites the four heads in the quest for truth. Christ's head is largely in shadow, as He is the person who is the least knowable. He also has a beauty that had not been evident in the Mattei paintings of His arrest and appearance at Emmaus.

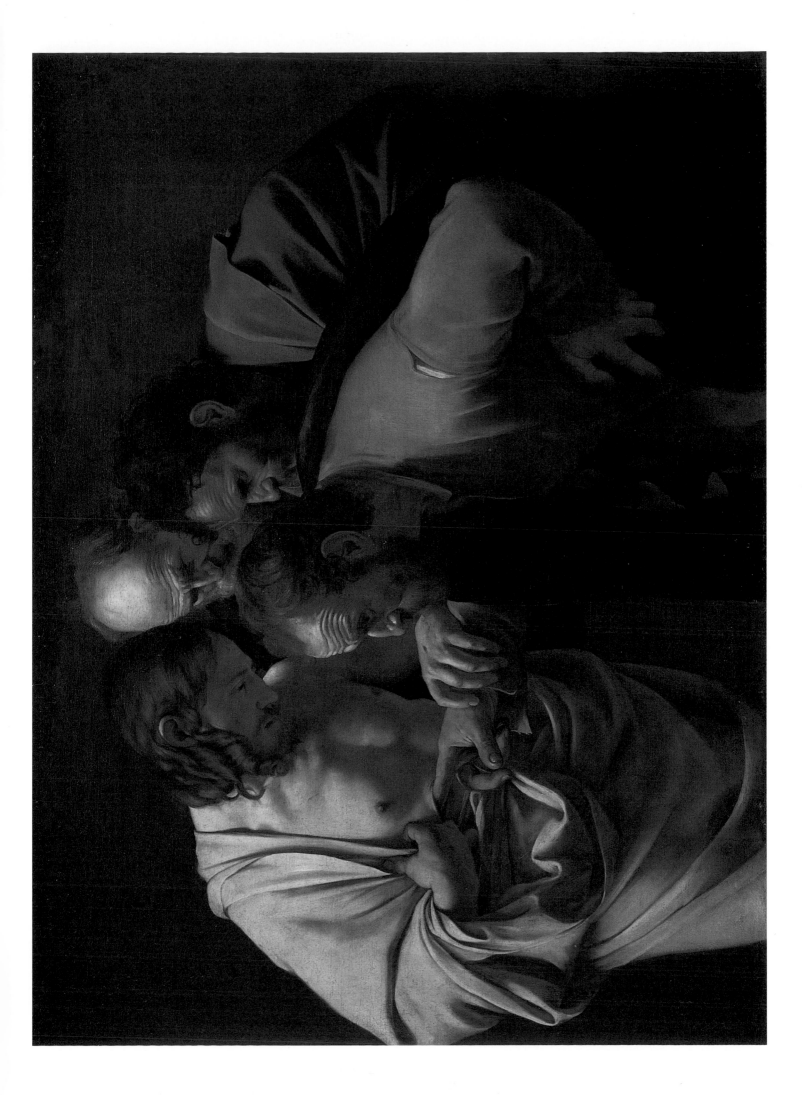

The Entombment

*c.*1602–4. Oil on canvas, 300 x 203 cm. Pinacoteca Vaticana, Rome

Fig. 33
SIMONE PETERZANO
The Deposition of
Christ
*c.*1575. Oil on canvas,
290 x 185 cm.
San Fedele, Milan

During his lifetime, though commonly called 'the best painter in Rome', Caravaggio never worked for the Pope. Of all his works this picture best harmonizes with the papal collection, for it has a monumental clarity of design.

It was painted originally for the 'Chiesa Nuova' of the Oratorians (Santa Maria in Vallicella), placed just above the altar of the Vittrice Chapel, so that Christ's body is laid into a tomb as worshippers watch. In St Paul's words, 'by baptism we are buried with Him.'

The theme had been treated in one of Raphael's most strained compositions, the 1507 Borghese *Entombment*, and in one of Michelangelo's most lyrical, the 1497–1500 *Pietà*, in St Peter's. Caravaggio would have known *The Deposition of Christ* by his master Peterzano (fig. 33), but he makes his composition more concentrated by placing all his figures except for Joseph of Arimathea in an arc that descends to Christ's body. He retains something of his North Italian roughness in the depiction of the mourners; and there is a touch of sadism in the way in which St John grips Christ in such a way as to open up the wound in his side. There is no denying the sense of antique grandeur that is given to the burial of God's Son; and perhaps that is why it was in the past Caravaggio's most popular painting.

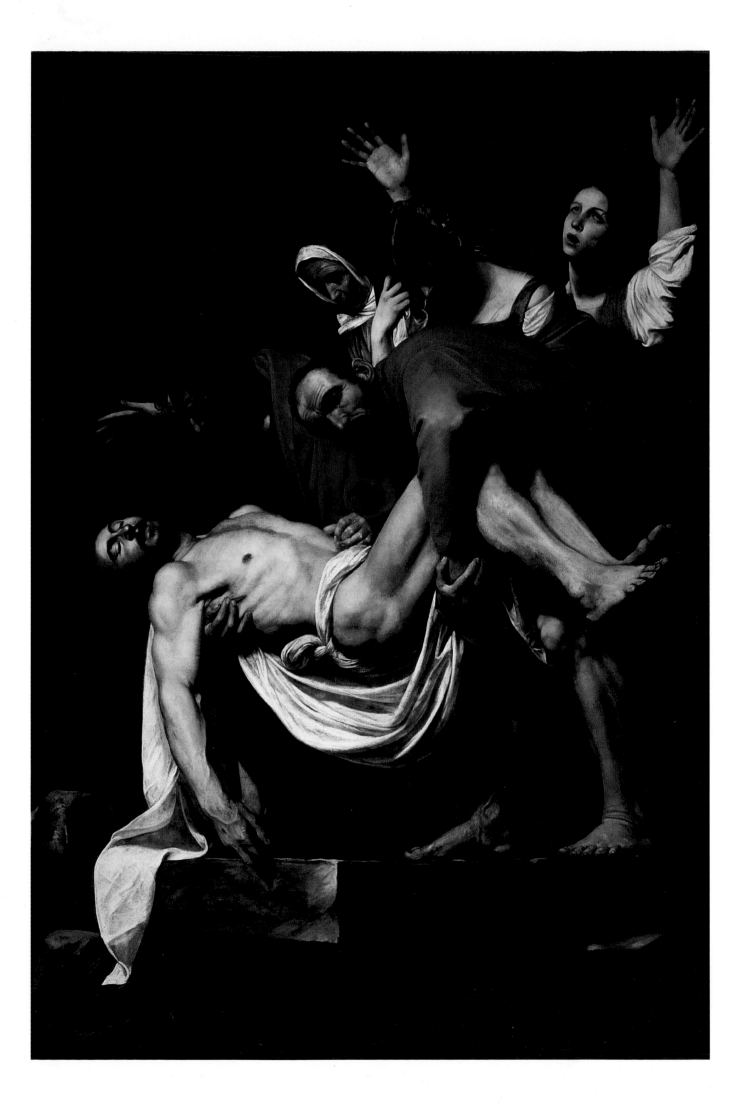

The Sacrifice of Isaac

*c.*1603. Oil on canvas, 204 x 135 cm. Galleria degli Uffizi, Florence

In 1603–4 Caravaggio painted a version of this subject for Cardinal Maffeo Barberini, the future Pope Urban VIII and this could be the picture.

The artist thrusts the action to the front of the picture frame like a sculpted frieze. Old Abraham, with features reminiscent of the second *St Matthew*, is intercepted in the act of slitting his son's throat by an admonishing angel who with his right hand prevents the murder and with his left points to the substitute victim. Light directs the viewer to scan the scene from left to right as it picks out the angel's shoulder and left hand, the quizzical face of Abraham, the right shoulder and terrified face of Isaac and finally the docile ram. A continuous movement links the back of the angel's neck to Isaac's profile; and angel and boy have a family likeness.

Caravaggio combines a hint of horror with pastoral beauty. In the foreground the sharp knife is silhouetted against the light on Isaac's arm. In the distance is one of Caravaggio's rare landscapes, a glimpse perhaps of the Alban hills round Rome and an acknowledgement of the skill of his one serious rival, Annibale Carracci, whose landscapes were particularly admired.

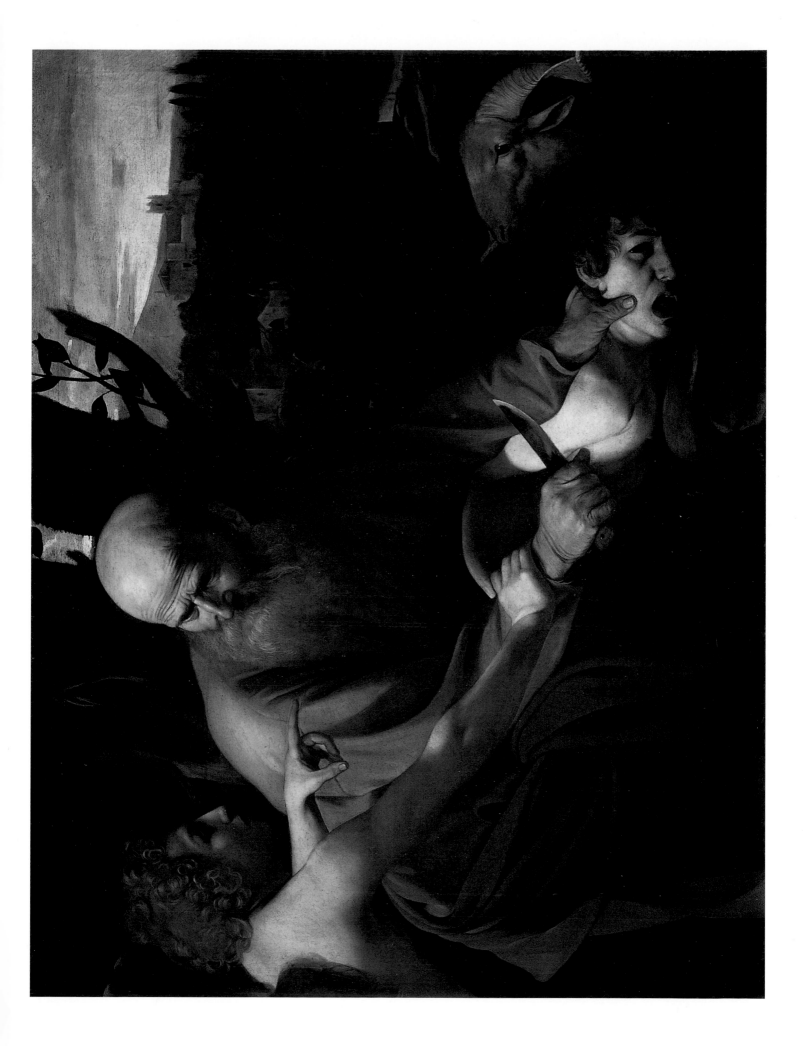

St John the Baptist

*c.*1603–5. Oil on canvas, 172.5 x 104.5 cm. Nelson-Atkins Museum, Kansas

This painting, according to Baglione, was ordered by the Genoese Ottavio Costa, who had a copy made for the family chapel in Cosciente in Liguria, where it is still to be found.

This is one of the few pictures where Caravaggio places his subject in a natural setting, here against leaves and with a plant at his feet. To emphasize the Baptist's role as last of the prophets, Caravaggio borrowed ideas from the Sistine Chapel ceiling – his John is as melancholy as Michelangelo's Jeremiah and he has the disquiet of one who will cry out in the wilderness. The sharp outlines of the body, possibly bathed in moonlight, and the swirling fiery red cloak carelessly draped about him emphasize the latent force of John's youthful personality, which was to precipitate him into public life to call the rich and powerful to repentance. His eyes are hidden in shadow. When questioned about John's ministry, Jesus asked the interrogators: 'What went you out to see? A man clothed in soft raiment?' The Baptist that Caravaggio reveals, with a stick and animal pelt to serve him as a loincloth, finds his natural home in the desert.

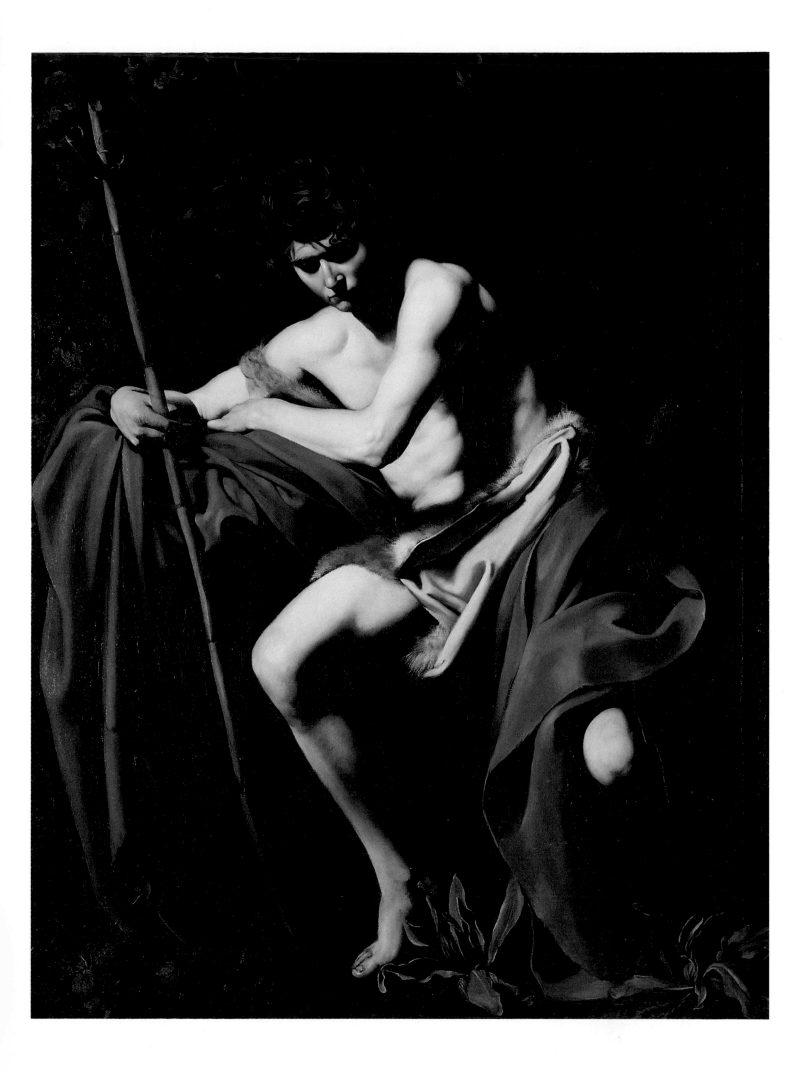

Madonna di Loreto

*c.*1603–6. Oil on canvas, 260 x 150 cm. San Agostino, Rome

In 1603 money was given by the heirs of one Ermete Cavalletti for the decoration of the family chapel in the church of San Agostino, not far from the Piazza Navona, at the centre of Caravaggio's Rome. By the end of 1604 this painting was installed in a spot where it has been ever since. In the winter of 1603–4 Caravaggio had been in Tolentino, not far from the shrine of Loreto, and he may have gone there to see the supposed Holy House of Nazareth.

He has made simple devotion affecting. Two pilgrims – *pellegrini* in Italian – kneel in prayer before the statue beside a pillar, while the Madonna and Child, living to the eyes of faith, look down on them in quiet attention. The woman has a ruckled bonnet and the dirty soles of the man's feet are so close to the spectator that they cannot be avoided. The haloes on the sacred figures and their raised position remove them from our world, but their beauty contains no hint of arrogance – they gaze at the world with gentle sympathy.

Some have seen in this Madonna the latest woman in Caravaggio's life, Lena or Maddalena, over whom he had a fight. She is painted with love, but has only one rich passage in the left arm of her dress; elsewhere colour is toned down. Her craning neck was to be almost a mannerism in Caravaggio's works of this period, but here the pose is convincing.

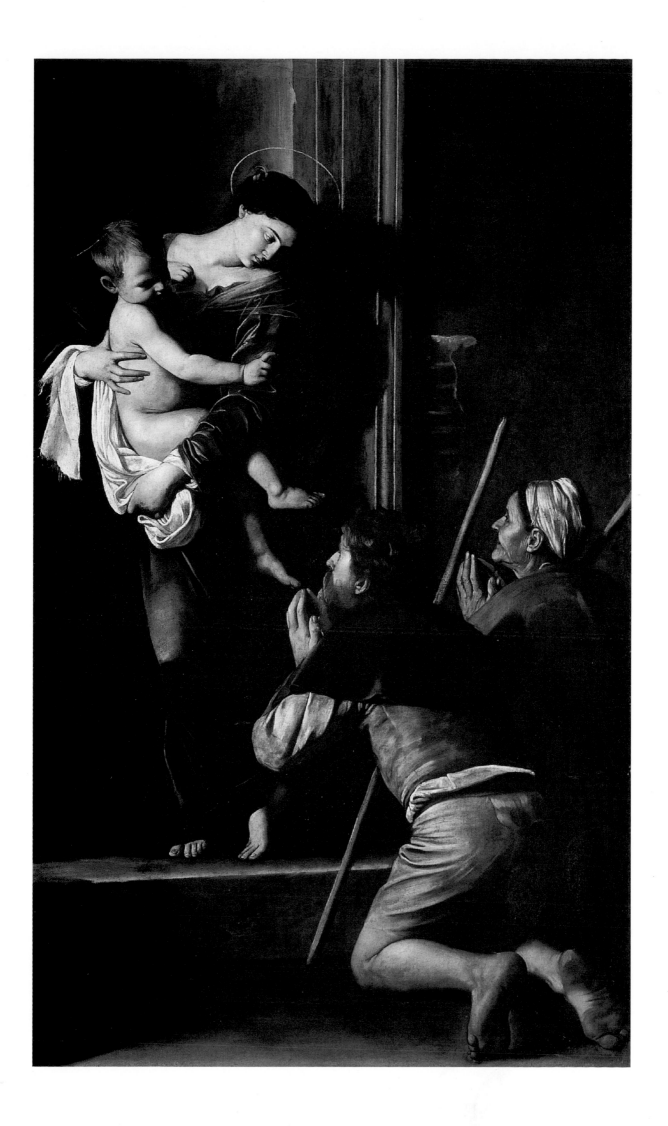

Madonna dei Palafrenieri

1605–6. Oil on canvas, 292 x 211cm. Galleria Borghese, Rome

It was in late 1605 that Caravaggio finally obtained a commission for St Peter's. The papal grooms or *palafrenieri* invited him to paint an altarpiece for them, and in April 1606 it was exhibited in the basilica for a few days before being moved to the grooms' church of Sant'Anna nearby. If the sympathy of Paul V had facilitated the commission, his nephew soon profited by it, for later in the year, just after the painter had left Rome for good, it was added to the Borghese collection.

Under the watchful gaze of St Anne, Jesus's apocryphal grandmother, Mary helps a naked Christ Child to tread on a snake. The snake may be interpreted as Satan and indirectly as heresy, for Mary and Jesus are free of sin and its consequences, Mary as a virgin mother and by reason of her Immaculate Conception, Jesus as God made man – and they combine to crush the serpent under their feet.

This large iconographic canvas has a certain humanity thanks to Mary's naturalness and the lack of inhibition with which Caravaggio depicts Christ naked (a fact that gave offence to some connoisseurs at the time, according to Bellori). Though their haloes are aligned, a dark gulf separates the pretty Mary from her ugly mother; and if the *palafrenieri* were willing to let Cardinal Scipione Borghese buy the picture so soon after they had received it and paid for it, it may have been because they disliked the unflattering depiction of their patroness.

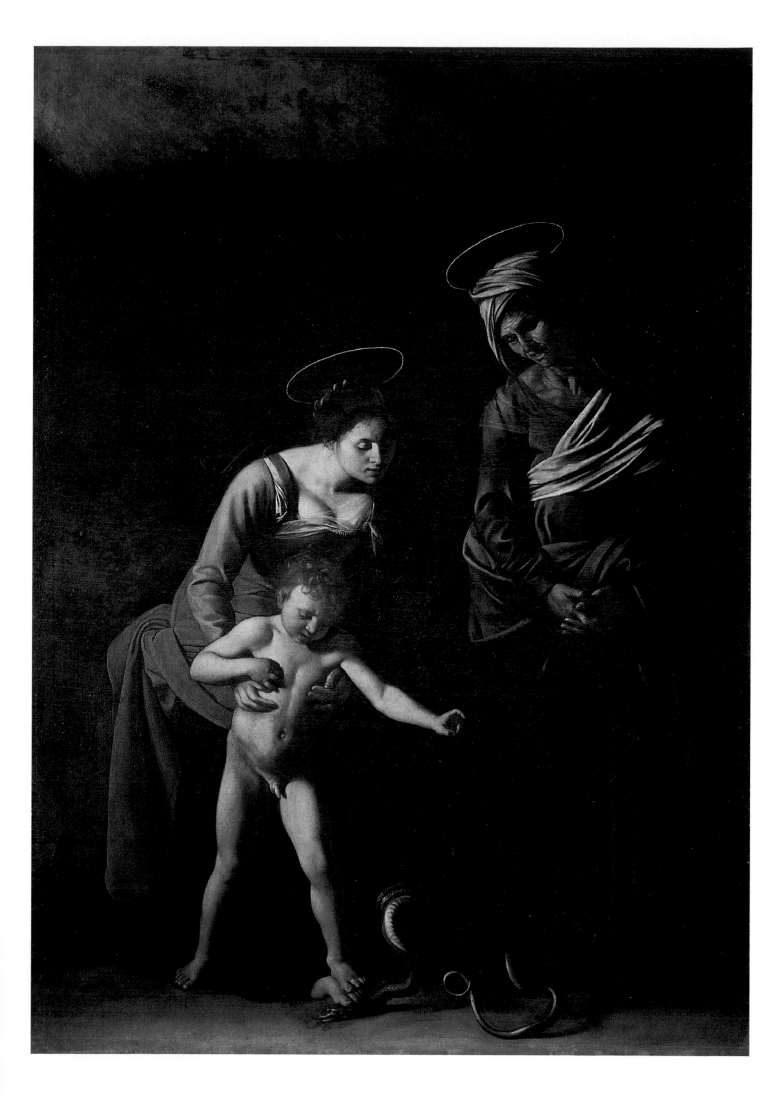

33 St Jerome

*c.*1605. Oil on canvas, 112 x 157 cm. Galleria Borghese, Rome

Just as Protestants wished to translate the Bible into local languages to make the Word of God accessible to ordinary believers, so Catholics were keen to justify the use of the standard Latin version, made by St Jerome in the late fourth century. Jerome had been baptized by one pope, had been given his task as translator by another and had called St Peter the first bishop of Rome. Among the Latin Fathers of the Church he was a powerful ally against modern heretics, who attacked the cult of the saints, restricted the use of Latin to the learned and viewed the papacy as the whore of Babylon. It was wholly appropriate that this image was bought by Scipione Borghese soon after he was made a cardinal in 1605 by his uncle, the new Pope Paul V.

In pre-Reformation days Jerome was shown with a pet lion and a cardinal's hat. Now Catholic reformers wished to pare religious art down to its essentials, and the good-living cardinal, whose ample features were to be sculpted and caricatured by Bernini, acquired a painting that was as austere as it was sombre. The thin old man, whose face is reminiscent of the model who had been Abraham, Matthew and one of the Apostles with Thomas, sits reflecting on a codex of the Bible while his right hand is poised to write. Whereas in the Renaissance, Antonello da Messina and Dürer had made him into a wealthy scholar, Caravaggio reduces Jerome's possessions to a minimum. The text he holds open, a second closed one and a third kept open by a skull are perched on a small table. Harsh lighting emphasizes the sinewy muscles of his tired arms and the parallel between his bony head and the skull – man is born to die, but the Word of God lives forever.

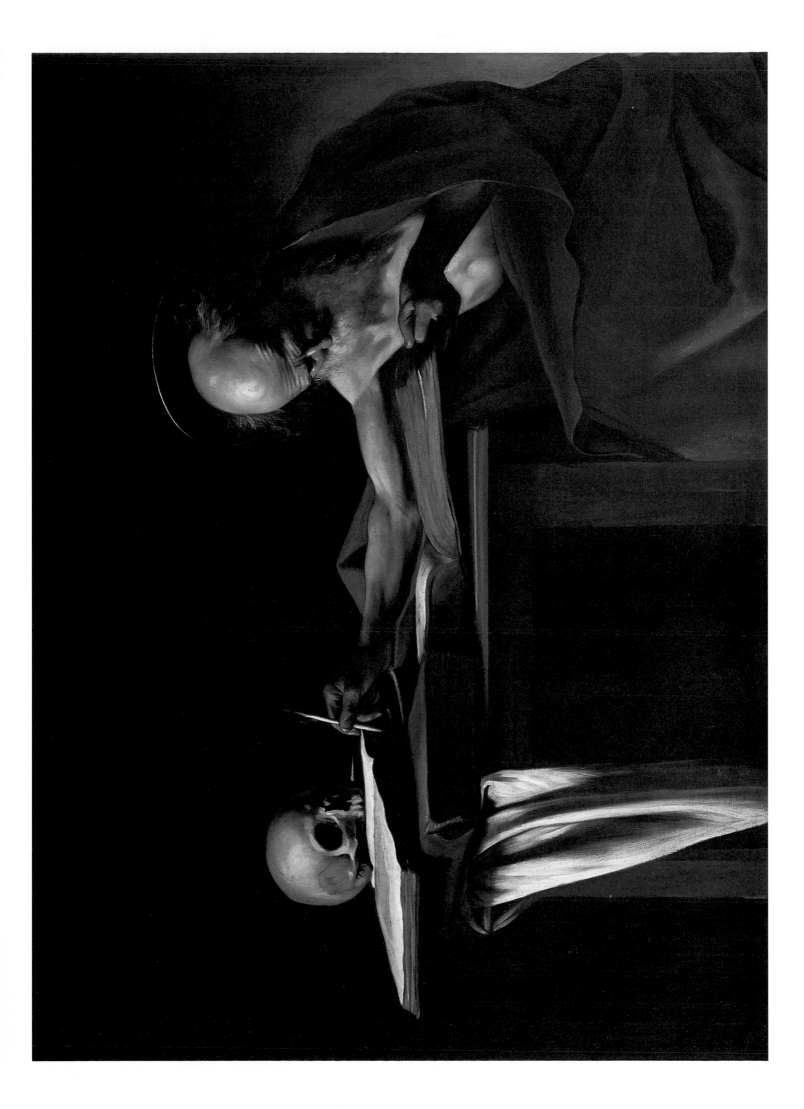

Supper at Emmaus

1606. Oil on canvas, 141 x 175 cm. Galleria Brera, Milan

Mancini mentions that in Zagarolo, 'where he was secretly housed by the Prince' (Don Marzio Colonna, Duke of Zagarolo) following his murder of Ranuccio Tomassoni, Caravaggio painted a *Magdalen* and a *Cristo va in Emmaus* (Christ goes to Emmaus), which was later sold to the Costa brothers. Only copies of the *Magdalen* survive and there is no picture of Christ walking towards Emmaus with two disciples, so this scene set after their arrival in the village may well have been the one that Mancini meant. From 1624 till 1939 it was owned by the Patrizzi family.

This version is more restrained in colour and action than the Mattei version now in London (Plate 20), less symbolic, more reverential. An elderly innkeeper and an elderly maid wait anxiously on the three men who have arrived in the small village. The disciple to the left turns his face away towards Christ, the one on the right is seen in three-quarter profile. This time, instead of recoiling from Christ, they lean forward in His direction, as with a tranquil gesture He blesses the bread. A diagonal line links the disciple on the left, Jesus and the host; Christ is slightly to the left of centre, and the second disciple and the maid are at the back right. The scene is ordered peacefully. Christ's gown is blue-green, the disciple on the left wears a cloak in which old gold, greys and earthy browns predominate, and nothing is so striking as to detract from the contemplative mood.

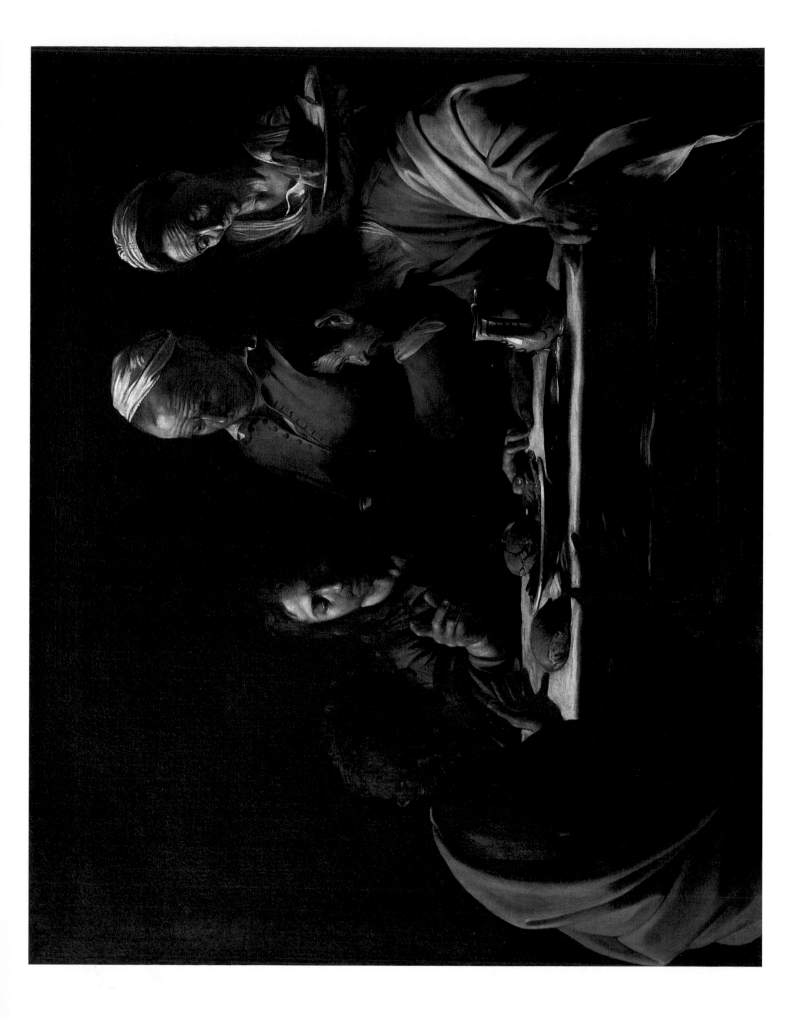

Seven Works of Mercy

1606–7. Oil on canvas, 390 x 260 cm. Pio Monte della Misericordia, Naples

Fig. 34
The Dying Gaul
*c.*200 BC. Marble, height
(with plinth) 93 cm, length
(of plinth) 186.5 cm,
breadth 89 cm.
Musei Capitolini, Rome

In January 1606 the Pope, from whose jurisdiction Caravaggio was fleeing, had granted to the Neapolitan congregation of the Misericordia the right to have a privileged altarpiece. In September 1606 Caravaggio set to work on producing an enormous vertical picture and by January 1607 he had finished it.

Six of the seven corporal Works of Mercy derive from Christ's list in the 25th chapter of St Matthew's Gospel: giving food to the hungry and drink to the thirsty, giving the stranger shelter, clothing the naked, tending the sick and visiting those in prison. To these was added the seventh duty of burying the dead. This picture takes a novel line by linking Christian charity to devotion to Mary, Mother of Mercy.

High above, a pale, tender Madonna of the Lena type (see Plate 34), together with her Child, looks down at a crowd past two angels embracing in swirling wings and draperies, while the left-hand angel extends his left hand towards the people and parts them into two groups. Below on the left is a darkened street scene, where an innkeeper welcomes three strangers: a middle-aged pilgrim (he has a staff and in his hat St James of Compostella's shell and St Peter's keys); a young officer (St Martin), who cuts his cloak in half to clothe the naked man at the front; and an obscure young man who must be sick. Behind, Samson drinks from the jawbone of an ass. To the right a priest with a candle and his clerk bury a dead man whose feet protrude towards the viewer, while in the next passage, Caravaggio takes an example of filial piety from antiquity, in the story of Cimon and Pero, who accomplishes two works of mercy at once by breastfeeding her father in prison.

Caravaggio has a knack of making disparate elements cohere; and this right side of the painting is unified by patterns of colour (grey-white, gold-brown, green). St Martin stands out as the best-dressed man, wearing a red cloak, a gold shirt, dark green doublet and dun hose. The other figures lack his flamboyance. The naked man may derive from the Hellenistic statue of the Dying Gaul (fig. 34).

This painting's power derives from inventive lighting. In a dim Neapolitan church, flickering candles would conceal many inadequacies, and the spectator gazes at an odd and oddly fascinating vision: of a beneficent Madonna and Child; of ecstatic angels; of a group of holy men who walk down the dingy alleys of an old town; and of a strange example of daughterly piety.

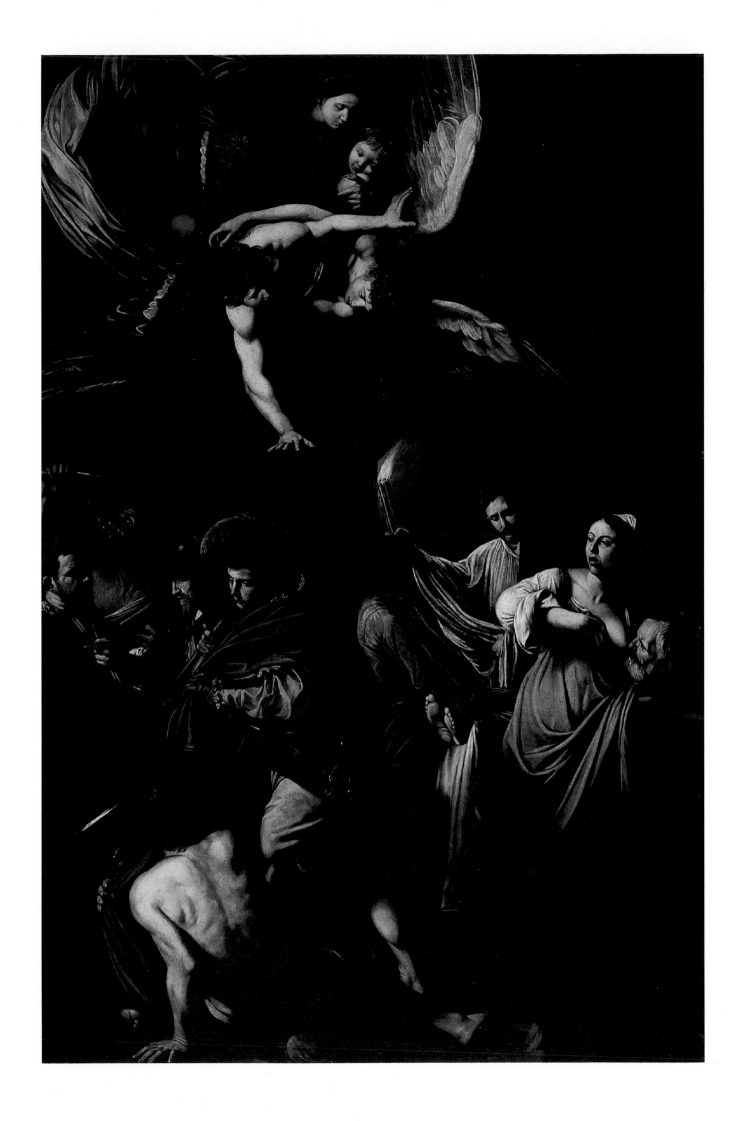

Madonna of the Rosary

*c.*1606–7. Oil on canvas, 364 x 249 cm. Kunsthistoriches Museum, Vienna

In its huge scale and multi-figured design the grandest of Caravaggio's paintings, this may have been commissioned by the Duke of Modena in 1605 and undertaken in Naples. It was offered to the Duke of Mantua in 1607 and was bought by a consortium of Flemish artists, including Rubens, by whom it was offered to the Dominican church in Antwerp.

The theme is Dominican. St Dominic and his friars spread the devotion of the rosary; and here the Madonna, as Queen of Heaven, issues orders to the saint to her right, who clutches a rosary, and the Dominican St Peter Martyr to her left. Beside St Peter Martyr stands the most famous of Dominican theologians, St Thomas Aquinas.

Madonna, Child and saints form a heavenly triangle concealed from the classically costumed suppliants at the front, who kneel in prayer with arms outstretched to St Dominic, while a donor in modern ruff and doublet eyes the viewer. The column to the left and the curtain overhead add to the formality of the scene. Caravaggio achieves an elaborate ordering and interlocking of forms that heralds the typical Baroque altarpiece.

The Flagellation of Christ

1607. Oil on canvas, 286 x 213 cm. Museo di Capodimonte, Naples

Fig. 35
Sebastiano Del
Piombo
Flagellation
c.1521. Oil on
prepared wall.
San Pietro in Montorio,
Rome

This major painting, which (like the *Seven Works of Mercy*) dates from Caravaggio's first visit to Naples, is disquieting in its own special way. In May 1607 he was paid by Tommaso de' Franchis for an altarpiece to hang in the family chapel in San Domenico, where it stayed till 1972.

The atmosphere is so dense that the pillar before which Christ is being whipped can hardly be made out, but the handling of paint is so fluent that the cruel action taking place has its own powerful rhythm. The viewer is caught up in the horror.

The near-naked Christ is being twisted into position by the torturer on the right while the torturer on the left tears at his hair. At the bottom left a third tormentor stoops to prepare his scourge.

The composition is derived from a fresco by Sebastiano del Piombo (fig. 35), but its restricted palette of dismal colours gives it a grim force that few earlier paintings had equalled.

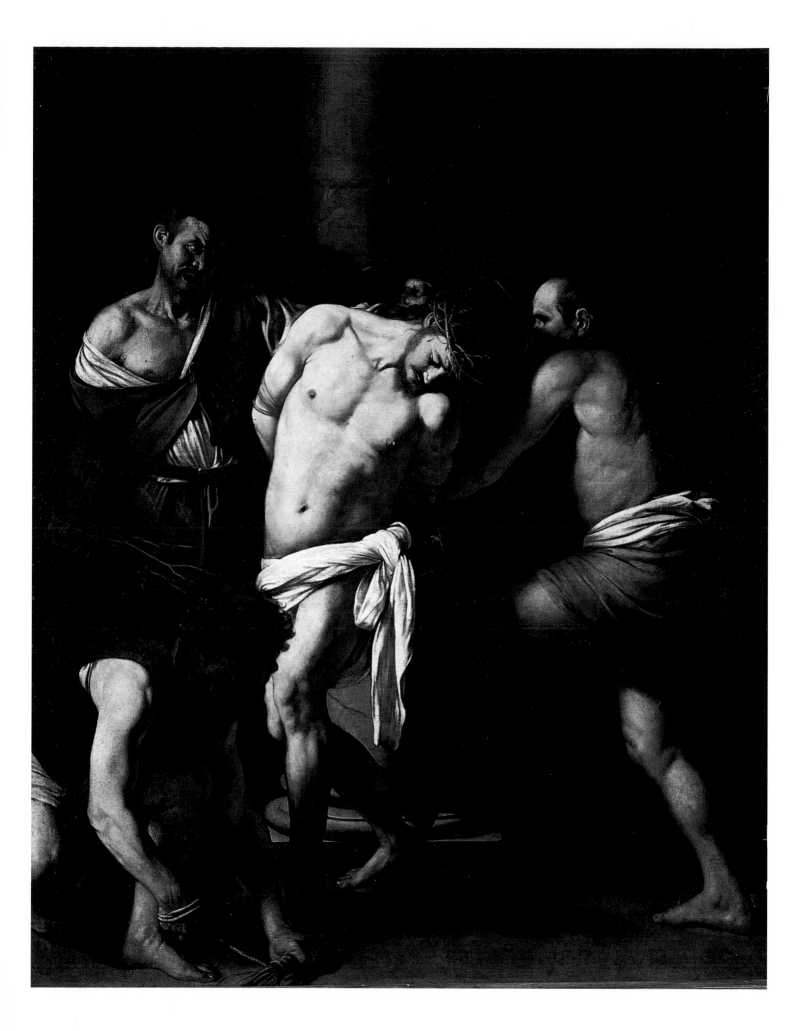

St Jerome

*c.*1607–8. Oil on canvas, 117 x 157 cm. Co-Cathedral of St John, Valletta

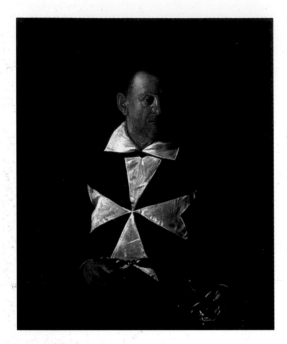

Fig. 36
Portrait of a Knight of
Malta.
*c.*1608. Oil on canvas,
72 x 105 cm.
Palazzo Pitti, Florence

This picture of the holy scholar was made for Ippolito Malaspina, a Maltese knight whose coat of arms is on the wooden panel to the right. He was connected by marriage to Caravaggio's patron Ottavio Costa and was a confidant of the Grand Master, who may have been used as the model for the saint (similarly Van Dyck was to use the sister of the Queen of England as model for the Madonna). The saint does indeed look like the knight in a recently discovered portrait by Caravaggio, who has been identified by some as Wignacourt himself (fig. 36).

The composition is planned in terms of triangles. One rises from the table to the saint's head, another has its apex at the cardinal's hat on the wall to the left, a third recedes to the bedstead at the back on the right. This simple design helps convey an idea of simplicity. St Jerome has no halo, his workbench is rudimentary, he does not own any folios, he has one candle to see by, a crucifix to meditate on, a stone to beat against his chest, and a skull to remind him of his mortality. He is partly naked because he lives an eremitical life in the desert of Judaea. A steady light shines on his torso and picks out the red cloak round his legs. The source of the light is outside the picture, and can be interpreted as Christ, Light of the World.

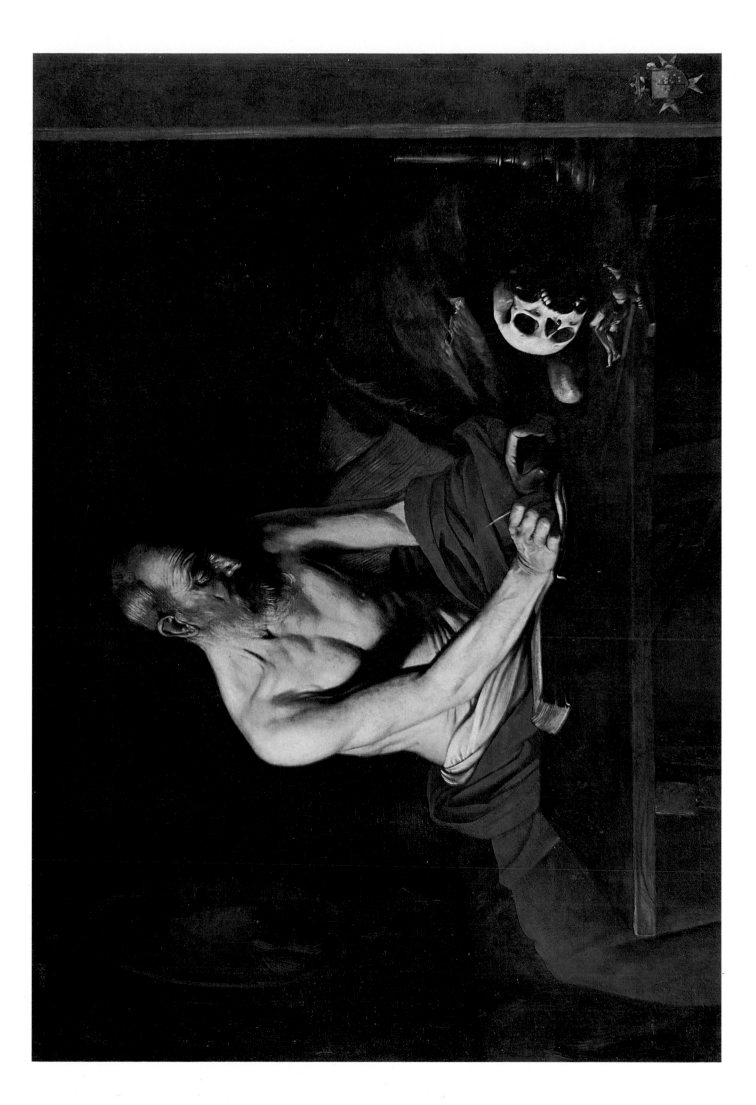

*c.*1607–8. Oil on canvas, 195 x 134 cm. Musée du Louvre, Paris

Fig. 37
TITIAN
Alfonso d'Avalos,
Marchese del Vasto,
Addressing the
Troops
1541. Oil on canvas,
223 x 165 cm.
Museo del Prado, Madrid

In 1644 the diarist John Evelyn saw this picture in Paris, where it may have been taken by Wignacourt when he visited France in the 1620s.

As Grand Master of the Knights of St John of Malta, he was head of a military order and a sovereign state, and he commissioned this portrait and maybe the second (fig. 36) which was probably the model for St Jerome.

The page in charge of Wignacourt's plumed helmet and cloak stands a little awkwardly within the composition, and his lively features would make him an attractive subject in his own right. Caravaggio may have been attempting to rival the portraiture of Titian, whose Marchese del Vasto harangs his troops with his pageboy at his side (fig. 37).

Wignacourt is consciously dignified, relaxed and authoritative. His splendid black and gold Milanese armour glints in the light. Even if he was left-handed, the way he holds the baton, pointing upwards in his right hand and downwards in his left, is uncomfortable. As a reward for this painting Wignacourt gave the painter an honorary knighthood, but within three months the relationship had deteriorated and Caravaggio had fled in disgrace.

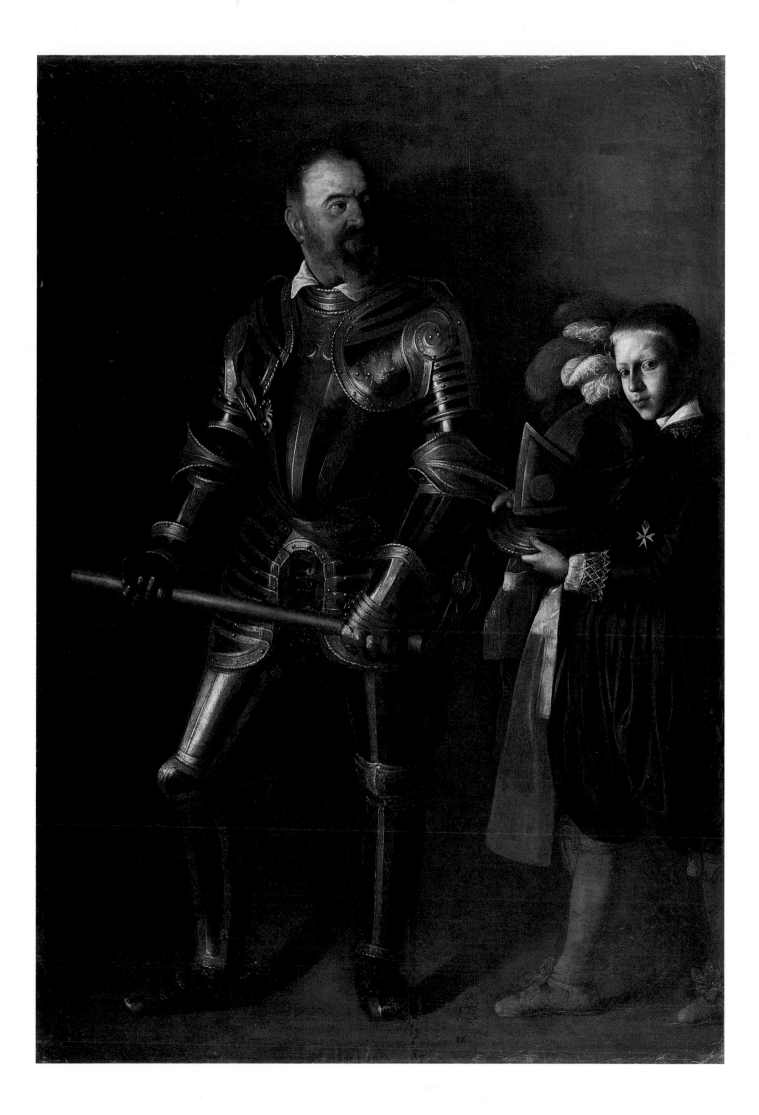

The Beheading of St John the Baptist

1607–8. Oil on canvas, 361 x 520 cm. Co-Cathedral of St John, Valletta

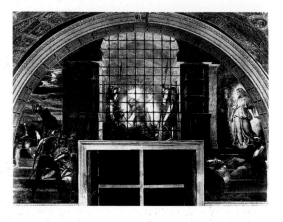

Fig. 38
RAPHAEL
Deliverance of
St Peter
*c.*1512–13. Fresco.
Stanza d'Eliodoro,
Vatican, Rome

Nothing by Caravaggio equalled in scale the magnificent altarpiece he painted for the cathedral of Malta. His chief pictorial inspiration came from Raphael's murals in the Vatican Stanze, with their constant interplay between rectangles and semicircles, their confident placing of figures in architectural space, their studied calm. If he remembered one of the frescoes more than any other, it was the *Deliverance of St Peter* (fig. 38). Of Caravaggio's late works, none is more grandly Roman.

Imprisoned behind their rectangular bars, two dimly lit prisoners on the right look over towards the left-hand side of the scene, where five figures form an arc: Salome with the charger on which the head of the Baptist is to be placed; her old servant, who watches with her hands to her head in grief; the impassive gaoler, whose right hand indicates the charger; the naked executioner, leaning forward to his victim whose head he will prize off with a knife clutched behind his back; and on the floor St John. The Baptist is already dead, for the sword with which he has been killed lies abandoned on the ground.

For a death scene there is a still restraint that may surprise the reflective spectator (and Caravaggio's painting is coolly contemplative). Large areas of the picture space are blank. The principal actors wear dark green, black, brown, white and grey. Only the Baptist, as a martyr, is prominent because he is clothed in red, the colour of blood; and in a trickle of blood that reads F[ra] Michel A[ngelo] the painter has signed his name, the only time his signature has been found. In this macabre way he has identified himself with the action, for he seems to have been obsessed with the idea of violent death by sword or by knife.

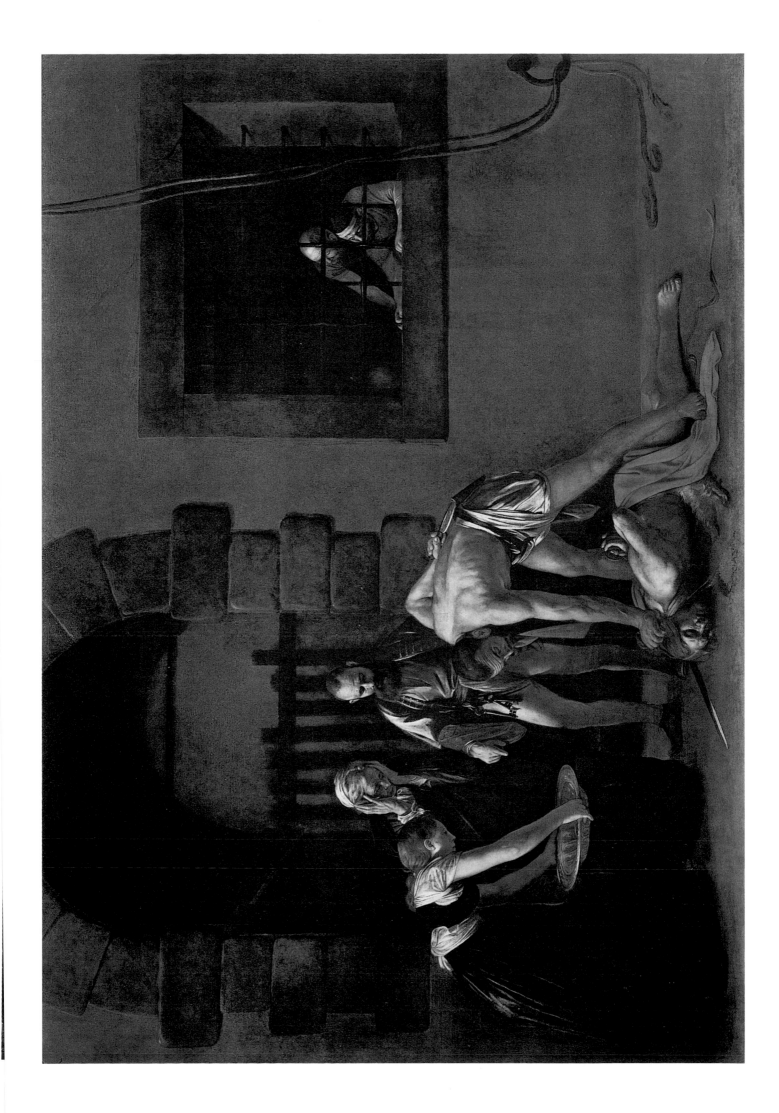

The Raising of Lazarus

*c.*1608–9. Oil on canvas, 380 x 275 cm. Museo Regionale, Messina

Most of Caravaggio's religious subjects emphasize sadness, suffering and death. In 1609 he dealt with the triumph of life and in doing so created the most visionary picture of his career.

Lazarus, the brother of Martha and Mary, was the patron of Giovanni Battista de' Lazzari, to whom Caravaggio was contracted to paint an altarpiece in the church of the Padri Crociferi. The Gospel of St John tells how Lazarus fell sick, died, was buried and then miraculously raised from the dead by Christ.

Once again, the scene is set against blank walls that overwhelm the actors, who once more are laid out like figures on a frieze. Some of them, says Susinno, were modelled on members of the community, but at this stage Caravaggio did not have time to base himself wholly on models and relied on his memory – the whole design is based on an engraving after Giulio Romano (fig. 40) and his Jesus is a reversed image of the Christ who called Matthew to join him (Plate 17).

There is a remarkable contrast between the flexible bodies of the grieving sisters and the near-rigid corpse of their brother. In the gospel Martha reminds Jesus that, as her brother had been dead four days, he would stink, but here nobody detracts from the dignity of the moment by holding his nose. Jesus is the resurrection and the life and in the darkness through him the truth is revealed.

Fig. 40
DIANA GHISI AFTER
GIULIO ROMANO
Achilles Bearing the
Body of Patroclus
Engraving, 23.9 x 39.1 cm.
British Museum, London

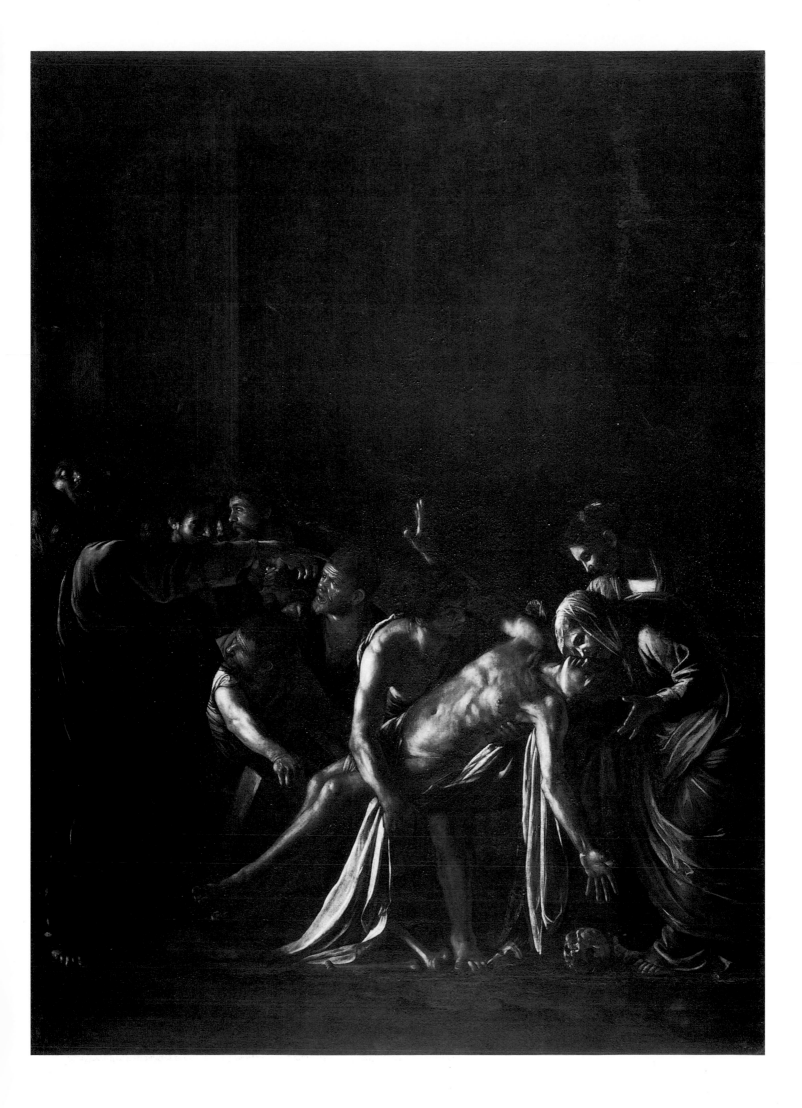

The Adoration of the Shepherds

1608–9. Oil on canvas, 314 x 211cm. Museo Regionale, Messina

While in Messina, Caravaggio was contracted to paint four scenes of the Passion. If he finished any of them, nothing now survives. This nativity scene, Susinno says, was ordered by the Senate of Messina for the Capuchin church of Santa Maria degli Angeli. A Franciscan simplicity pervades it: in the wooden barn a donkey and an ox stand patiently at the back, there is straw on the floor and in a basket the Holy Family have a loaf of bread, the carpenter's tools of Joseph and some pieces of cloth. Joseph (in red) introduces the shepherds, in brown and grey, to the young Virgin Mother, whose dress is a brighter red. Mary cuddles her baby peacefully and, apart from two haloes, only the bare-shouldered young man, who kneels with clasped hands, gives the moment of the child's discovery a hint of its meaning. God became man as one of the poor. Ironically, for this canvas Caravaggio received 1000 scudi, the highest amount mentioned in any accounts of his career.

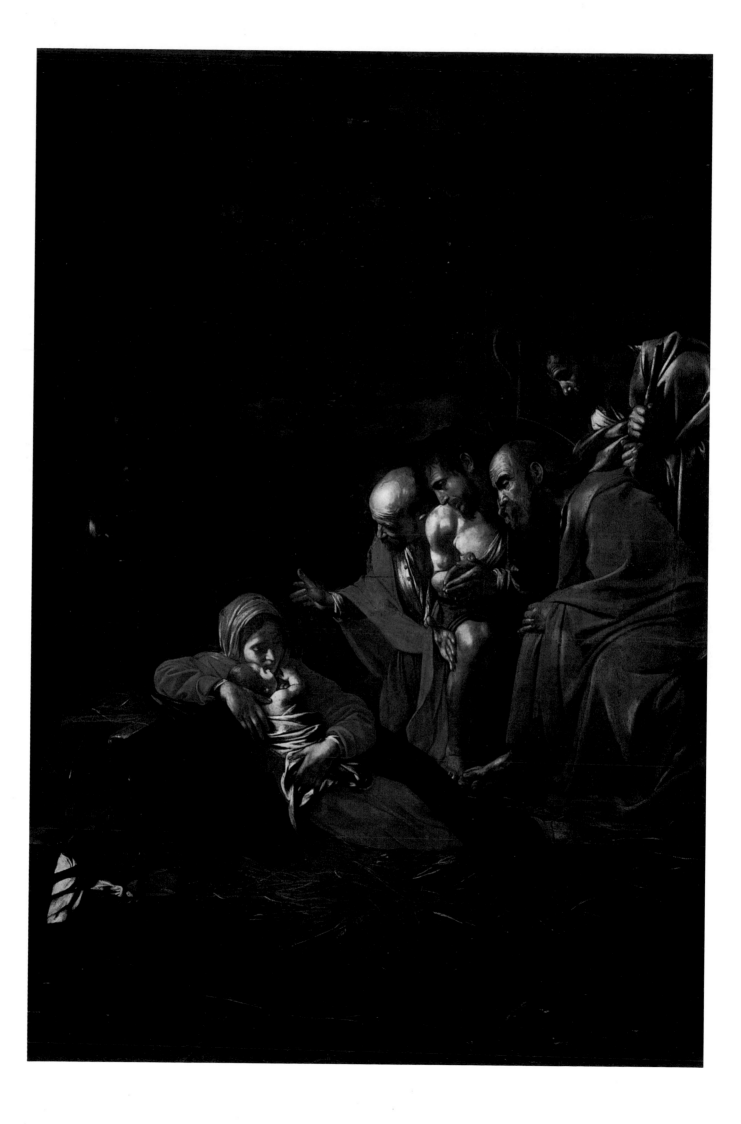

Salome with the Head of St John the Baptist

*c.*1609–10. Oil on canvas, 90.5 x 167 cm. National Gallery, London

Fig. 41
BERNARDINO LUINI
Salome Receiving the
Head of John the
Baptist
Tempera on wood,
51 x 58 cm.
Galleria degli Uffizi,
Florence

On his way back to Rome Caravaggio returned to Naples. This harsh late work has none of the beauty of some of the late Sicilian pictures, such as the altarpiece stolen from the Oratory of San Lorenzo in Palermo (fig. 12), and it may reflect the assault Caravaggio endured in the Osteria del Cerriglio in the city. A sense of the tired mood of one aware of the pointlessness of a ruthless vendetta pervades the painting.

The Baptist has been executed for denouncing Salome's mother Herodias over her illicit marriage with Herod. Caravaggio uses the device of planting two heads – Salome's and her maid's (or her mother's) – so close together that they seem to grow out of one body as the contrasting stages of youth and age. This had been a trait of Leonardo's, and the way that the head of St John is presented to the spectator recalls a picture by Leonardo's pupil Luini, whose Salome also looks away from her victim (fig. 41). The executioner takes no joy in what he has been commanded to do. He feels only a stunned emotion in keeping with the sombre tones that Caravaggio adopts.

The Martyrdom of St Ursula

1610. Oil on canvas, 154 x 178 cm. Banco Commerciale Italiana, Naples

This, another of the newly rediscovered paintings by Caravaggio, dates to his final weeks in Naples, before the ill-fated sea-trip back towards Rome and the pardon which was awaiting him. Saint Ursula was a popular Christian saint, remembered for her legendary refusal to marry a pagan Hun. Caravaggio has picked on the climactic moment of her martyrdom, when her frustrated suitor has just fired an arrow at her – here at point-blank range – which is piercing her breast.

In the dimly lit scene the saint gazes at the arrow with an air of quiet concern, while the Hun stares at her, his eyes shaded in darkness, one attendant looking at his hand and another, who must be modelled on Caravaggio himself, peering from the back, anxious to watch the proceedings. It is the last time that Caravaggio sees himself as an anguished spectator, but in pictorial terms the painting seems to presage what might have been a fresh stage in his career, for the Hun is painted with a new boldness in the brushwork. The varnish was still wet in May. In early July, Caravaggio was dead.

David with the Head of Goliath

*c.*1610. Oil on canvas, 125 x 100 cm. Galleria Borghese, Rome

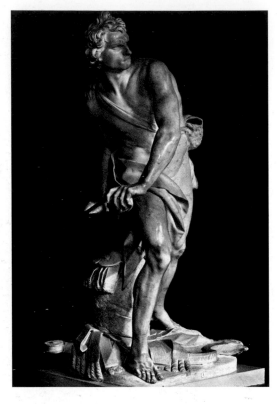

Fig. 42
GIANLORENZO
BERNINI
David
1623. Marble,
height 170 cm.
Galleria Borghese, Rome

Nobody knows which was Caravaggio's last work. This painting, which was in the collection of Scipione Borghese as early as 1613, has been dated as early as 1605 and as late as 1609–10. Its melancholy would suit the gloomy thoughts of the artist's final years. The subject matter recalls the *Beheading of St John the Baptist* in Valletta, but this time there is no brilliant colour and, as a small picture, it has an intimacy that was not evident in the grand public work.

The boy handles his trophy with disgust. 'In that head [Caravaggio] wished to portray himself and in the boy he portrayed his Caravaggino,' wrote Manilli in 1650. If Goliath's head is indeed Caravaggio's, there is an element of self-disgust in this painting. The device recalls the way that Michelangelo, in the *Last Judgement* for the Sistine Chapel, placed an anguished face with features evidently his own onto the flayed body of St Bartholomew, but Caravaggio's mood is closer to one of despair. As a witness to God's light, Bartholomew takes his seat in heaven: Goliath, God's enemy, is doomed to everlasting night.

Dirty silver, black and browns dominate the picture. The light shows David to look like a boy from the street, whose sword has just a drop of blood on it to show that, like Caravaggio once, he knows what it is to have just killed a man. Another drop of blood in the midst of the giant's forehead confirms that he has been felled by a stone.

A decade later Cardinal Scipione commissioned a statue of David about to catapult a stone at Goliath (fig. 42). Bernini was far removed from the anxieties of the older master, and saw David's action as joyful and exhilarating, a triumph of the human spirit expressing itself through the athletic exertions of a beautiful human body.

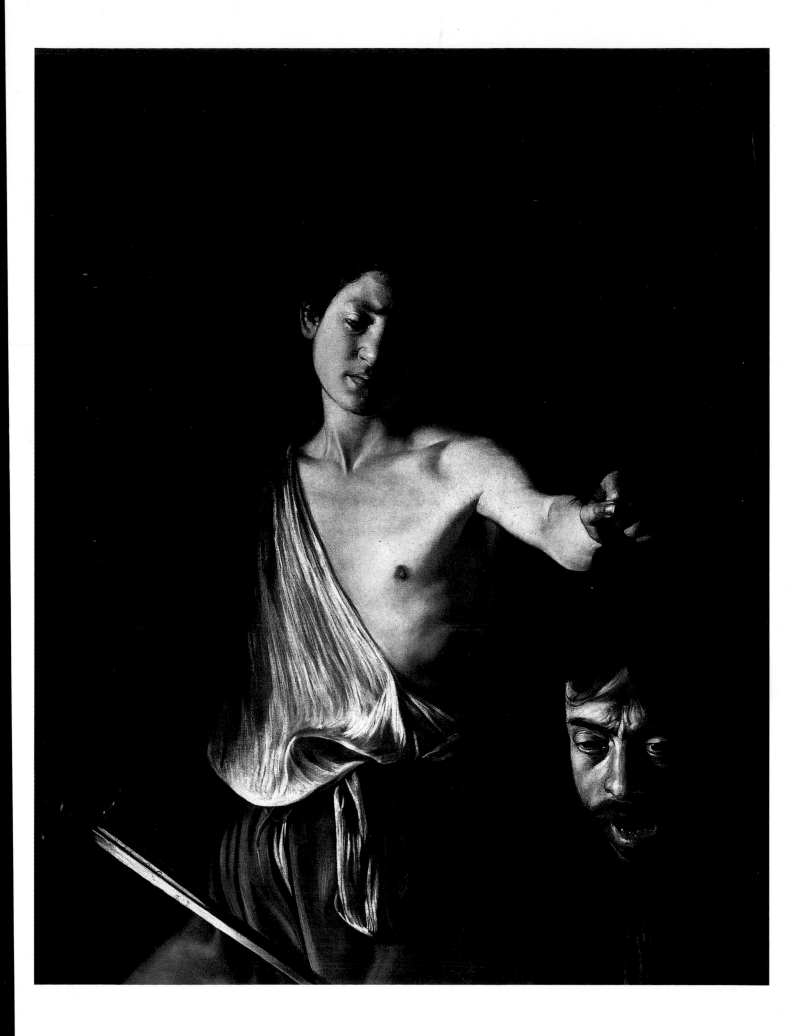

PHAIDON COLOUR LIBRARY
Titles in the series

FRA ANGELICO
Christopher Lloyd

BONNARD
Julian Bell

BRUEGEL
Keith Roberts

CANALETTO
Christopher Baker

CARAVAGGIO
Timothy
Wilson-Smith

CEZANNE
Catherine Dean

CHAGALL
Gill Polonsky

CHARDIN
Gabriel Naughton

CONSTABLE
John Sunderland

CUBISM
Philip Cooper

DALÍ
Christopher Masters

DEGAS
Keith Roberts

DÜRER
Martin Bailey

DUTCH PAINTING
Christopher Brown

ERNST
Ian Turpin

GAINSBOROUGH
Nicola Kalinsky

GAUGUIN
Alan Bowness

GOYA
Enriqueta Harris

HOLBEIN
Helen Langdon

IMPRESSIONISM
Mark Powell-Jones

**ITALIAN
RENAISSANCE
PAINTING**
Sara Elliott

**JAPANESE
COLOUR PRINTS**
J. Hillier

KLEE
Douglas Hall

KLIMT
Catherine Dean

MAGRITTE
Richard Calvocoressi

MANET
John Richardson

MATISSE
Nicholas Watkins

MODIGLIANI
Douglas Hall

MONET
John House

MUNCH
John Boulton Smith

PICASSO
Roland Penrose

PISSARRO
Christopher Lloyd

POP ART
Jamie James

**THE PRE-
RAPHAELITES**
Andrea Rose

REMBRANDT
Michael Kitson

RENOIR
William Gaunt

ROSSETTI
David Rodgers

SCHIELE
Christopher Short

SISLEY
Richard Shone

**SURREALIST
PAINTING**
Simon Wilson

**TOULOUSE-
LAUTREC**
Edward Lucie-Smith

TURNER
William Gaunt

VAN GOGH
Wilhelm Uhde

VERMEER
Martin Bailey

WHISTLER
Frances Spalding